Quarto is the authority on a wide range of topics.

Quarto educates, entertains and enriches the lives of our readers—enthusiasts and lovers of hands-on living.

www.quartoknows.com

First published in 2017 by Voyageur Press,
an imprint of Quarto Publishing Group USA Inc.,
400 First Avenue North, Suite 400, Minneapolis, MN 55401 USA.
Telephone: (612) 344-8100 Fax: (612) 344-8692

quartoknows.com
Visit our blogs at quartoknows.com

Voyageur Press titles are also available at discounts in bulk quantity for industrial or sales-promotional use. For details contact the Special Sales Manager at Quarto Publishing Group USA Inc., 400 First Avenue North, Suite 400, Minneapolis, MN 55401 USA.

10 9 8 7 6 5 4 3 2 1

ISBN: 978-0-7603-5162-8

Library of Congress Cataloging-in-Publication Data

Names: Hinckley, Jim, 1958- author. | Hinckley, Judy, photographer.
Title: Route 66 : America's longest small town / text by Jim Hinckley; photography by Jim Hinckley and Judy Hinckley.
Description: Minneapolis, MN : Voyageur Press, 2017.
Identifiers: LCCN 2016039068 | ISBN 9780760351628 (paperback)
Subjects: LCSH: United States Highway 66—Guidebooks. | United States Highway 66—History. | United States Highway 66—Pictorial works. | BISAC: TRAVEL / United States / West / Mountain (AZ, CO, ID, MT, NM, UT, WY). | PHOTOGRAPHY / Subjects & Themes / Regional (see also TRAVEL / Pictorials). | TRAVEL / United States / West / General.
Classification: LCC HE356.U55 H5587 2017 | DDC 917.804/34—dc23
LC record available at https://lccn.loc.gov/2016039068

Acquiring Editor: Todd Berger
Project Manager: Alyssa Bluhm
Art Direction and Cover Design: Cindy Samargia Laun
Page Design and Layout: Simon Larkin

Cover photo © Andrey Bayda/Shutterstock
Back cover photo © trekandshoot/Shutterstock

Printed in China

ROUTE 66

AMERICA'S LONGEST SMALL TOWN

TEXT BY
JIM HINCKLEY

PHOTOGRAPHY BY
JIM HINCKLEY AND
JUDY HINCKLEY

VOYAGEUR
PRESS

The Steel Horse

Honoring Mike Landis
Respected Rancher & Cowboy

Dedicated May 2014

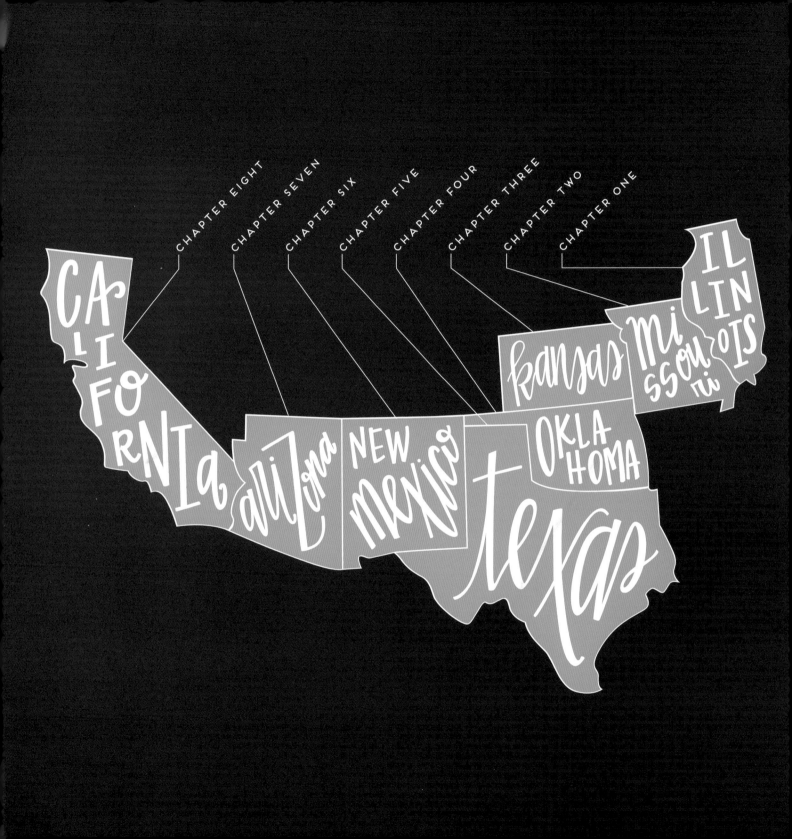

CALIFORNIA

ARIZONA

NEW MEXICO

TEXAS

OKLAHOMA

KANSAS

MISSOURI

ILLINOIS

CONTENTS

ACKNOWLEDGMENTS

The theme from *The Twilight Zone* would be a fitting backdrop to the story of my association with iconic Route 66. My family's first trip west was on Route 66 in 1959. In 1966, we moved west to Arizona—on Route 66.

On the bypassed pre-1952 alignment in the shadow of the Black Mountains in western Arizona, I learned to ride a bicycle and to drive. My first paying job was in the garden at Ed's Camp, a business that traced its origins to the era of the National Old Trails Highway, predecessor to Route 66.

My wife's family owned and operated an auto court and small grocery on Route 66 for several decades. When we began dating, I would drive into Kingman on Route 66 from Ash Fork. The first time we crossed the Mississippi River together as husband and wife, it was on Route 66. In fact, most milestones in my life are linked to this amazing old highway.

What makes Route 66 truly special are the people—the ones who travel the road and organize festivals, in the United States and abroad, the ambitious and daring people who restore motels or cafés, and the families that have managed businesses on Route 66 for decades through hard times and good times.

It is the Route 66 people affectionately referred to as "roadies" who inspired this book and that, as with the highway itself, give it a sense of vibrancy. It would be impossible to acknowledge everyone who provided assistance or inspiration. There are a few, however, who merit special mention.

The first of these is my dearest friend, my wife of more than thirty-three years, who is also a talented photographer. Without her steadfast support and encouragement, none of the fourteen books published to date would have ever been more than an idea or dream.

Dries and Marion Bessels, and fellow members of the Dutch Route 66 Association, provided valuable perspective and insight about Route 66 in the era of renaissance. Likewise, Wolfgang and Anja Werz, Zdenek and Eva Jurasek, Swa Frantzen and Nadine, Dale Butel, Toshi Goto, George and Bonnie Game, Sam Murray, and the legion of international Route 66 enthusiasts that we are privileged to call friends.

Daring entrepreneurs such as the Mueller family, the Brenners, Connie Echols, Allan Affeldt and his wife Tina Mion, Gary and Lena Turner, Laurel Kane, and so many others who have taken on the task of preserving the special places also deserve special mention. Then there are the pioneers, the people such as Bob and Ramona Lehman, Nick Adam and his family, and the Delgadillo family, that kept the lights on when it looked as though Route 66 was about to become little more than a historic footnote.

To each and every one who contributed to this book, thank you. And to those who make Route 66 something truly unique and special, thank you.

INTRODUCTION

Route 66 is firmly rooted in the nation's historic roads and trails that were born of our insatiable quest for greener pastures and curiosity about what was over the next hill. The Pontiac Trail and Wire Road, Ozark Trails Highway and Santa Fe Trail, Spanish Trail and National Old Trails Highway, Beale Wagon Road, and Mojave Road are the foundation for what is, arguably, the most famous highway in the world.

However, unlike these roads and trails that became historic footnotes after being rendered obsolete by the nation's evolving transportation needs, Route 66 remained relevant. It has also continued to evolve even though, technically, it no longer exists as a US highway.

From that perspective, it is rather fitting that Route 66, in the twenty-first century, has transitioned into a living, breathing time capsule. Though certification of US 66 occurred in 1926, there are tangible links to centuries of American societal evolution along the highway's corridor from Chicago to Santa Monica.

It is America's longest attraction. Museums, festivals, scenic wonders, neon-lit landmarks, and classic tourist traps entice travelers from throughout the world to travel the storied highway where the past, present, and future intersect seamlessly.

In 1927, a marketing campaign branded US 66 as the Main Street of America, a descriptor that is still fitting even though the highway officially ceased to exist in 1984. John Steinbeck referred to it as the "Mother Road" in *The Grapes of Wrath* a decade later. Then, in 1946, Bobby Troup penned the highway's anthem, and Nat King Cole had most everyone in the country singing a tune about getting your kicks on Route 66.

However, as exciting as the glory days of Route 66 in the 1940s and 1950s were, at least for the segment of American society not restricted by prejudice and segregation, in many ways they seem pale when compared to the era of the highway's renaissance. Today, there is a tangible, infectious enthusiasm found all along the route of the old highway and in the international Route 66 community.

Intertwined along the Route 66 corridor are ghost towns and abandoned truck stops, somber Civil War battlefields and dynamic cities, recently renovated motels and cafés, and businesses that have been under the same management for decades. When driving Route 66 today, you are almost as likely to meet travelers from Australia, Germany, or Japan as you are to meet someone from Alabama, Alaska, or Arizona.

From its inception, Route 66 was a road in a near-constant state of evolution. That trend continues today.

Electric vehicle charging stations share a place with vintage gasoline pumps at renovated historic service stations that now serve as information centers or gift shops. The Route 66 Electric Vehicle Museum, the first of its kind in the world, opened in Kingman, Arizona, in 2014. Formerly abandoned segments of highway with picturesque steel truss bridges are repurposed as bicycle corridors.

However, it is the travelers and business owners, the preservationists and the visionaries who make this highway truly unique and special, and who give it a sense of infectious enthusiasm. With animated tales of adventure, the people who travel Route 66 fuel its ever-growing international popularity, and Route 66 today is a linear community, the nation's longest small town.

This book is not merely another guide to iconic Route 66, an almost magical highway. It is a cultural odyssey. As we travel from the shores of Lake Michigan to the Pacific Coast, I will introduce you to some of the people who are at the heart of the highway's renaissance, as well as the places that ensure a journey along this highway is a memorable one.

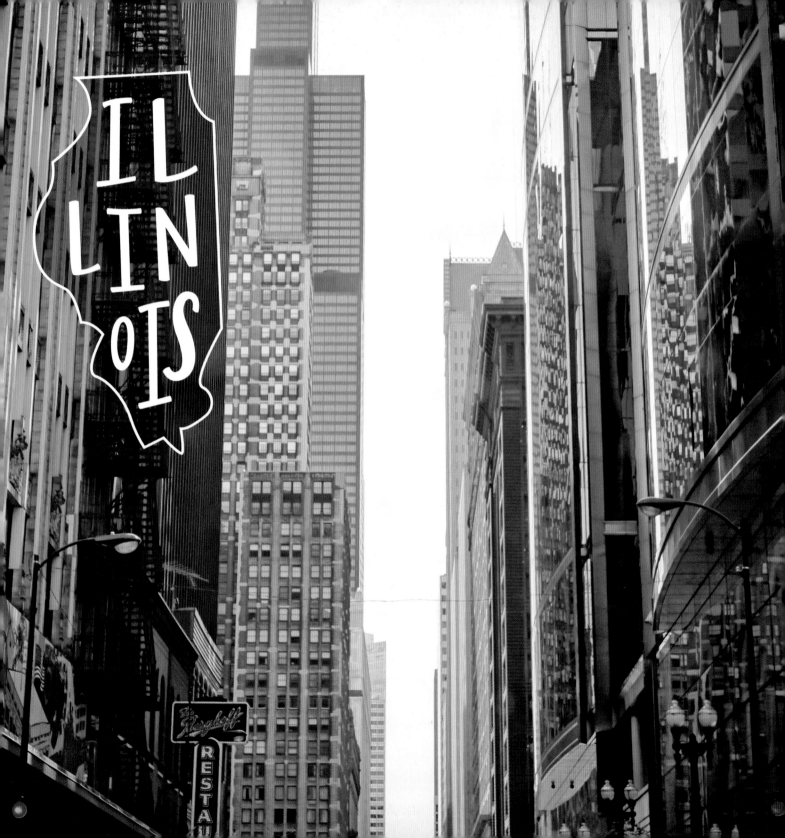

THE LAND OF LINCOLN

With the advent of the automobile, the nation's historic wanderlust was unleashed as never before. The exploits of daring "automobilists" garnered headlines and sold newspapers, their stories became bestselling books, and the great American road trip was born.

In 1903, Dr. Horatio Jackson of Vermont became the first person to make a transcontinental journey by automobile. Six years later, Norwegian-born A. L. Westgard, a former railroad surveyor, mapped thousands of miles of automobile roads, including the Trail to Sunset that linked Chicago with the Ocean-to-Ocean Highway at Yuma, Arizona.

In 1915, during the Panama-Pacific Exposition in San Francisco, more than twenty thousand people attended the event from outside the state of California. More than half of these traveled by automobile, including twenty-one-year-old Edsel Ford who also visited natural wonders such as the Grand Canyon on his western adventure along the National Old Trails Highway, predecessor to Route 66.

In the previous year, legendary racers Barney Oldfield, Louis Chevrolet, and other drivers followed the course for the last of the Desert Classic automobile races, derisively labeled as the Cactus Derby, along the National Old Trails Highway (Route 66 after 1926) from Los Angeles to Ash Fork in Arizona. Two years later, Emily Post chronicled her coast-to-coast adventure in a bestselling book, *By Motor to the Golden Gate*.

ABOVE

In 1915, Edsel Ford, then twenty-one years old, joined thousands of Americans on a grand adventure along the National Old Trails Highway. In 2015, the Historic Vehicle Association re-created his journey.

OPPOSITE

In Chicago, the path of Route 66 is through a manmade canyon that represents more than a century of urban architectural evolution. *Rhys Martin, Cloudless Lens Photography*

The seeds for the good roads movement sown in the national bicycle mania of the late nineteenth century and the establishment of the Wheelmen blossomed into a national obsession by the dawning of the new century. In 1902, nine auto clubs in the Chicago area joined to form the American Automobile Association, the AAA.

In 1912, a Daughters of the American Revolution initiative to knit a series of historic roads and trails into a coast-to-coast highway became manifest as the National Old Trails Highway, which followed portions of the Trail to Sunset. Fourteen years later, US 66 followed Westgard's pioneering road west through the heart of Chicago. These initiatives were the cornerstone for the US highway system.

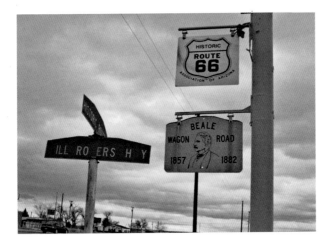

A common thread in the narrative about the infancy of a road network developed specifically for use by automobile owners is the fact that as with the railroad that preceded it, these roads linked the nation's cities. The benefit to rural America was tangible and dramatic, but for highway planners this was largely a secondary consideration. There is a certain irony in this.

At its inception and for decades to come, the cities were usually the primary destination for a journey on US 66. The towns and villages where Route 66 channeled traffic through town on Main Street were merely stops along the way, as were attractions such as the Grand Canyon or Painted Desert. Today in the era of the Route 66 renaissance, there is a reversal of roles. Small-town America is often the destination and cities are merely stops along the way.

Two of the nation's most dynamic metropolitan areas, cities filled with cultural diversity, historic sites, stunning architectural landmarks, and even scenic wonders, anchor Route 66 on the east and west. Yet the urban centers along the Route 66 corridor are among the least explored by enthusiasts, and these cities are primarily the communities that are slowest to capitalize on the potential for economic development and revitalization that the renewed interest in this historic highway offers.

Traffic congestion, parking, expense, misconceptions pertaining to crime, and related issues are in part to blame. Anemic or nonexistent Route 66–specific marketing is another problem. Chicago serves as an excellent example.

More than 80 percent of Route 66–specific travelers begin their adventure in Chicago. However, the majority pause for a photo stop at the eastern terminus of the highway, take in a few of the attractions in the immediate area such as Grant Park or the Navy Pier, visit Lou Mitchell's Restaurant (a favored Route 66 stop that opened initially in 1923), and then jump on the interstate highway for a speedy exit.

That is a rather sad state of affairs, as the theme for the entire Route 66 adventure is set amongst the architectural treasures, landmarks, and societal

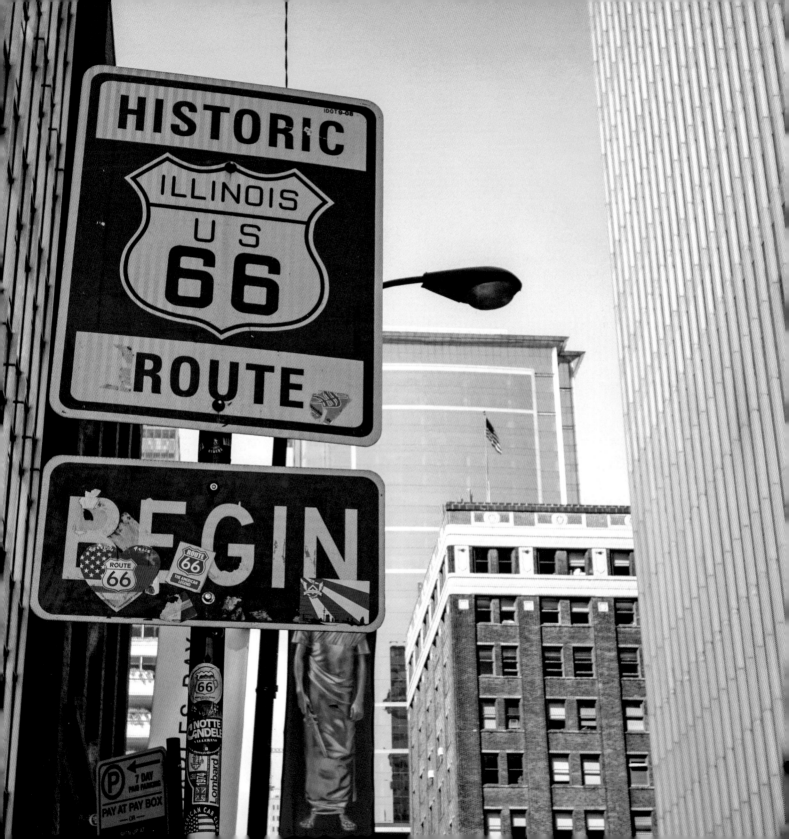

milestones that line the Route 66 corridors in Chicago and neighboring communities. Time-capsuled restaurants, forlorn abandoned relics from the era of "I Like Ike" buttons, historic sites, museums, and vestiges from more than a century of American societal evolution cast shadows over Route 66 in this metropolis; they are largely overlooked here. As Route 66 enthusiast and collector Mike Ward notes, "In any case, any 're-interest' from the larger metropolitan areas has been mostly left behind when compared with the smaller communities. That problem is particularly depressing to me as cities like Chicago, St. Louis, and Los Angeles has [*sic*] a massive amount of history relating to Route 66 due to more Route 66 alignments."

David Clark, a renowned author, historian, and Chicago-area tour guide who specializes in Route 66, says, "I hear it all the time—so many folks set out to 'do the route,' but instead of spending a little time in Chicago, they start their trip in Willowbrook at Dell Rhea's Chicken Shack. If they do come to Chicago, they eat at Lou Mitchell's, and perhaps they take a drive past the 'Route 66 begins' sign at Adams and Michigan for the ubiquitous touristy photo op. Then they go on their merry way. The excuses range from saying there is 'nothing else to see on 66 in Chicago' to 'we just do not want to fight the traffic.'"

Clark further noted, "I do give tours to groups of visitors as well as families who want to know the real story behind why Route 66 'winds from Chicago to L.A.' However, statistics indicate that many more folks explore the rural and small-town stretches of the Mother Road and virtually ignore the urban portions."

For those who take the time for a bit of urban exploration along Route 66 in Chicago beyond the classic stops, I doubt if they will be disappointed. I am also rather confident that it will enhance the overall adventure.

David Clark, in *Route 66 in Chicago*, says that "the Route 66 journey begins in Chicago for reasons historic and contemporary, and commercial and utilitarian. It is time to get our kicks on Chicago's Route 66."

Historian and author John Weiss in *Traveling the New, Historic Route 66 of Illinois* expands on that thought: "Many people who do Route 66 are anxious to hit the road and discover small-town America. But to really enjoy your Historic 66 tour, you should experience everything about the highway. You are starting at one of the greatest cities in America."

The urban gem that is the Berghoff Restaurant is but one example of the wonders awaiting discovery during a Route 66 odyssey in Chicago. The oldest continuously operated restaurant on Route 66 first opened its doors at State and Adams Streets in 1898. During the era of Prohibition, the owners relocated the restaurant a few doors down to its present location.

Housed in buildings built in 1872, one year after the Great Chicago Fire, the delightful restaurant is a

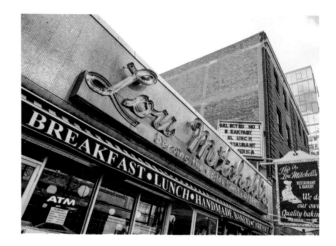

revered landmark. Still managed by the founding family, traditional German dishes remain the institution's trademark.

In 1953, the rerouting of westbound Route 66 funneled that highway's traffic past the Art Institute of Chicago building, built for the 1893 Columbian Exposition. This was just one of several realignments of Route 66 in Chicago. Initially, in 1926, the eastern terminus was located at the intersection of Michigan Avenue and Jackson Boulevard. Within a few years, realignment moved it to Jackson Boulevard and Lake Shore Drive, and then when Jackson Boulevard and Adams Street received designation as one-way streets, westbound Route 66 followed Adams Street.

As a result, Route 66 passes through the historic heart of the city's business district, the legendary Loop. Lining that corridor are buildings that represent more than a century of architectural change.

The Rookery Building is one example. Built in 1888 at the corner of La Salle and Adams Streets, this building

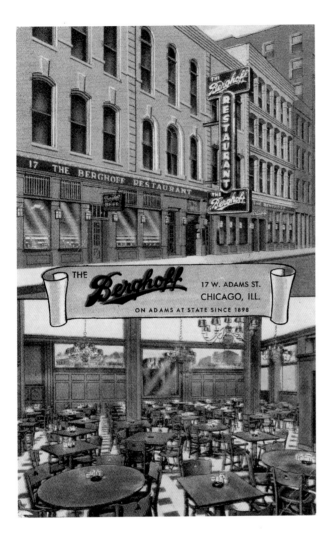

The Berghoff that opened in 1898 is the oldest continuously operated family-owned restaurant on Route 66. *Joe Sonderman*

features an atrium remodeled by Frank Lloyd Wright in 1907. Another architectural landmark is the Railway Exchange Building built in 1904 that once housed the offices of the Atchison, Topeka & Santa Fe Railway, Chicago & Alton Railroad, and numerous Chicago-based railroad companies.

Another is the Willis Tower, formerly the Sears Tower, the tallest building on Route 66 and once the tallest in the world. For a truly unique view of this highway, try the transparent-floored observation platform.

Numerous apps and services are available to enhance the adventure, but enlisting the services of a knowledgeable guide is your best investment. In Chicago, David Clark, who bills himself as the Windy City Warrior, has researched the city and the Route 66 corridor through Chicago and the neighboring communities for years, and has shared his discoveries as a guide.

Leaving the city, Route 66 courses through some gritty commercial areas peppered with overgrown vacant lots, landmarks, intriguing architectural studies such as the Castle Car Wash building that dates to the 1920s, and an occasional hint that some neighborhoods are on the cusp of rebirth. There is even a detour necessitated by the undermining of the old highway by a quarry operation.

The neighboring communities of Cicero, Berwyn, and Lyons, as with Chicago, have yet to fully embrace the Route 66 renaissance or harness the power of resurgent interest in the highway. However, the colorful kiosks and light-blue Berwyn Route 66 banners attached to light poles on street corners leave little doubt that there is a growing awareness.

Still, interesting landmarks, restaurants, and museums provide a bit of incentive for a more lengthy exploration. Henry's Drive-In, with its signature giant hot dog and a sign that reads "A Meal in Itself," is an authentic Route 66 eatery that has been feeding travelers and locals for more than sixty years. In the era of renewed interest in Route 66, it has become a destination in itself.

In Berwyn, the small US 66 Museum at 7003 West Ogden is well worth a visit. For a great photo stop,

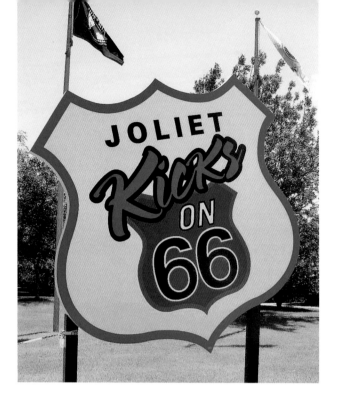

Plainfield is often overlooked as most Route 66 enthusiasts choose to follow Route 66 into Joliet. Plainfield is a surprisingly quaint community with a historic business district peppered with an interesting array of antique and specialty shops.

White Fence Farms is more than another historic restaurant. The display of vintage vehicles, a variety of electric games from pinball to arcade-style, rides, a free mini zoo, and other attractions ensure that it is a destination in itself. It exemplifies the type of business that has evolved with Route 66 while preserving its historic origins, as well as the type of business that was once common along American highways in the 1950s.

Joliet is a historic city that has fully embraced the resurgent interest in Route 66. From the Rich & Creamy stand in Kicks on 66 Park adorned with Blues Brothers figurines to the Joliet Area Historical Museum and Route 66 Welcome Center at 204 North Ottawa Street, Route 66 figures prominently in the community.

The interactive welcome center located at the crossroads of Route 66 and the historic Lincoln Highway is an award-winning museum for good reason. In addition to the large mural completed by internationally acclaimed artist Jerry McClanahan, the museum features a stellar gift shop, a two-story permanent exhibit, a Route 66 information center to provide assistance with the rest of the drive to California, and a multimillion-dollar series of interactive exhibits.

A Route 66 adventure is more than neon lights and tailfins, and sites and attractions associated with that highway, however, and these are but a few of the fascinating things to see in Joliet. The stunning Rialto Theater, built in 1926, at 102 North Chicago Street is an excellent example.

Often rated as one of the most beautiful theaters in America, and once considered for demolition, the

consider the intriguing 1908 Hoffman Tower on Joliet Avenue that houses the Lyons Historical Museum.

A landmark of particular note in Willowbrook is Dell Rhea's Chicken Basket with its signature neon sign. Established in 1946, this classic restaurant is another destination for the modern Route 66 enthusiast. Bridging the era of the restaurant's opening and the road's newfound popularity is a display of paintings by Jerry McClanahan, the author of the *EZ 66 Guide for Travelers*, arguably the most popular guidebook to Route 66 ever published, and extensive displays of Route 66 memorabilia.

Near Plainfield, at exit 268, the Route 66 explorer has two options: The post-1930s alignment largely obliterated by construction of Interstate 55, or Joliet Road and State Highway 53, which served as the course for Alternate 66 as well as the earliest alignment of that highway. My suggestion is the earlier alignment into Joliet, if for no other reason than to stop at White Fence Farms, another roadside classic, this time with roots reaching back to the 1920s.

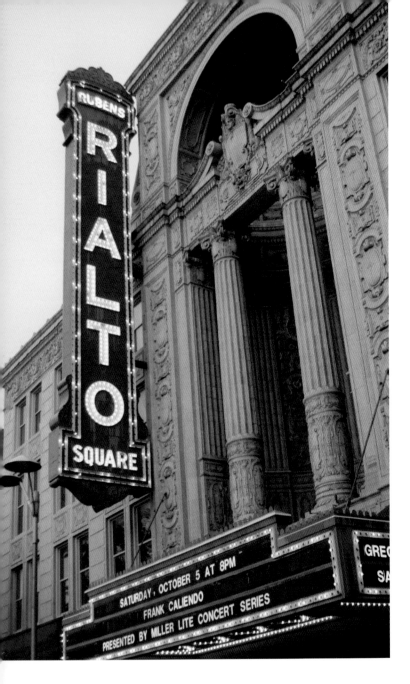

The stunning Rialto Theater is an architectural masterpiece and one example that a Route 66 journey is more than tail fins and neon.

renovated theater with its towering marquee and imposing neoclassical façade are stunning. The grand interior features more than one hundred hand-cut crystal chandeliers, Roman architectural elements, and a Barton Grande organ that rises hydraulically from the floor. Tours are available. In addition, group tours and tour/dining packages are also available.

An excellent way to explore the historic district that embraces the Route 66 corridor is the walking tour that starts at the Route 66 visitor center. The city has ingeniously incorporated things such as replica vintage gasoline pumps that serve as informational kiosks into this self-guided tour that includes the Rialto Theater.

Not quite as cheerful as the theater but just as interesting is another attraction of note, the Collins Street Prison and Prison Park. The imposing stone prison, which opened in 1858 and closed in 2002, has the dubious distinction of being the longest-operating correctional facility in the country. It also has a lengthy association with television programs and motion pictures as the prison has served as a filming location for a number of productions.

Shortly after leaving Joliet, the landscapes that embrace Route 66 (State Highway 53) take on a distinctly bucolic nature. However, they are also symbolic of the ever-changing nature of the Route 66 corridor.

In 1940, the sprawling Joliet Arsenal complex dominated large swaths of these prairies. In June 1942, a massive explosion at the Elwood facility left sixty-eight men dead, maimed, or missing. In 1999, 982 acres of the former facility were set aside as the Abraham Lincoln National Cemetery that includes the Hampton Station historic site. On May 3, 1865, President Abraham Lincoln's funeral train stopped at this station en route to Springfield.

Another eighteen thousand acres represents one of the largest prairie reclamation projects in the country. The Midewin National Tallgrass Prairie is a role model for similar endeavors, and in 2014, for the first time in almost two hundred years, American bison are again roaming the prairies of Illinois.

Another land reclamation project of note is located near Godley. The K Mine Park transformed lands ravaged by decades of mining into a delightful park with shaded picnic areas, hiking trails, and a ballpark.

Recently, a brilliantly conceived promotion for the Route 66 corridor in Illinois linked that highway with Abraham Lincoln. Peppered all along the highway corridor are sites associated with the sixteenth president. As the course of the road follows much of the Pontiac Trail, a Native American trade route transformed into a major transportation corridor in the American colonial era, there are also an array of other historic sites as well.

A superb example of these historic sites is located in Wilmington. The Eagle Hotel, originally an inn and stage station, opened in 1837 or 1838, which makes this the oldest commercial structure on the Route 66 corridor in Illinois. Over the years, the building located at 100 Water Street housed an array of businesses, including a hotel, a bank, and a tavern. Currently vacant and for sale, the building represents an incredible opportunity for anyone with imagination, investment capital, and ambition who is looking for a unique business opportunity.

Wilmington is a charming community nestled on the banks of the Kankakee River. The Historic Water Street Shopping District that stretches along North Water Street and the Mar Theater at 121 South Main Street are a detour of mere blocks from Route 66.

Built in 1937, the theater seems rather ordinary and plain in comparison to the Rialto Theater. However, it is equally as historic as it retains its original marquee and is the oldest continuously operated theater in Will County.

Long before the marketing of Route 66 as the Main Street of America, this was coal country. Now, however, with the exception of Braidwood, the towns of Godley, Braceville, and Mazonia are mere shadows of the mining boomtowns they once were. Preserved at the Illinois Route 66 Mining Museum in Godley, 150 South Kankakee Street, are the colorful histories of that bygone era, as well as an array of unique fossils from the Pennsylvanian Period. For those individuals who prefer the adventure of finding fossils in their native habitat, the nearby Mazonia/Braidwood Fish and Wildlife Area is world renowned for discoveries made in the park and on the shores of the finger lakes that are on lands reclaimed from a former strip mine.

Gardner is an intriguing stop that exemplifies the quirky, intriguing things you find all along the Route 66 corridor. It also is just another glimpse at what the resurgent interest in Route 66 means to small, forgotten, out-of-the-way little communities.

Platted in 1861, the town depended heavily on agriculture for its economic vitality even after the commissioning of Route 66. In 1946, Jack Rittenhouse noted in *A Guide Book to Highway 66* merely that there were gas stations and a café.

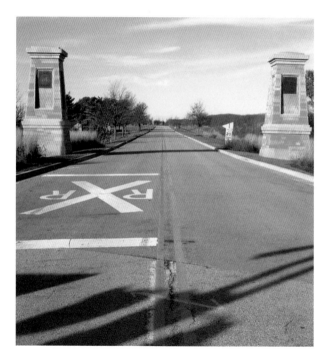

ABOVE
The entrance to the Abraham Lincoln National Cemetery presents
a sense of timeless serenity.

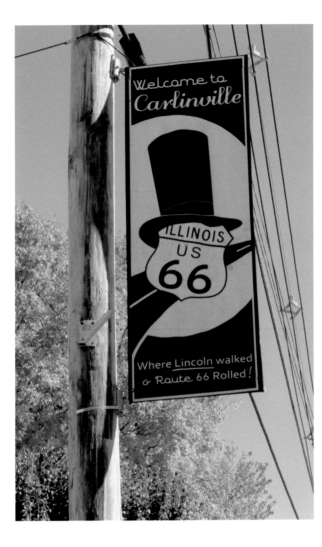

Today the town is, perhaps, more popular than ever with Route 66 travelers. On my recent visit to the town's sturdy two-cell jail built in 1906, the guest registry for that week indicated visitors from six countries and ten states. Located on the grounds in a parklike setting is a monument to the Reverend Christian Christiansen, a forgotten hero of World War II who played an instrumental role in the prevention of the Third Reich from developing nuclear capabilities, along with the Streetcar Diner.

The latter began life more than a century ago as a streetcar in Kankakee, Illinois. In 1932, after its relocation to Gardner, conversion transformed it into a roadside diner. Five years later, another remodel transformed it into a cottage. Restoration by the Illinois Route 66 Association preserves it as a nonfunctioning diner.

In regards to the Route 66 renaissance, Dwight represents a unique type of community. The city has openly embraced the past, present, and even the future of Route 66. Yet, some of its most fascinating attractions thrive even though enthusiasts overlook them since the historic city center is a few blocks from that highway corridor.

In the 1940s, the state of Illinois initiated an innovative series of highway improvements that included the construction of bypass alignments that skirted communities to expedite traffic flow and alleviate the bottlenecks associated with traversing city centers. In most communities, this resulted in a migration of service-industry business, while in others it gave a decided advantage to the outlying businesses that found themselves located at the junction of Bypass 66 and the main.

The Ambler/Becker Texaco Station located at the intersection of Waupansie Street, US 66, and Bypass 66 is a landmark of particular note. Built in 1933, it is purportedly the longest continuously operated service station on Route 66, with fuel pumped until 1999. After extensive repairs and restoration to a circa 1940s appearance, it reopened as a Route 66 visitor center in 2007. The recent addition of an electric vehicle–charging station and bicycle stands hint of the future for Route 66.

There is a growing initiative to transform Route 66 into an electric vehicle–friendly highway. In addition,

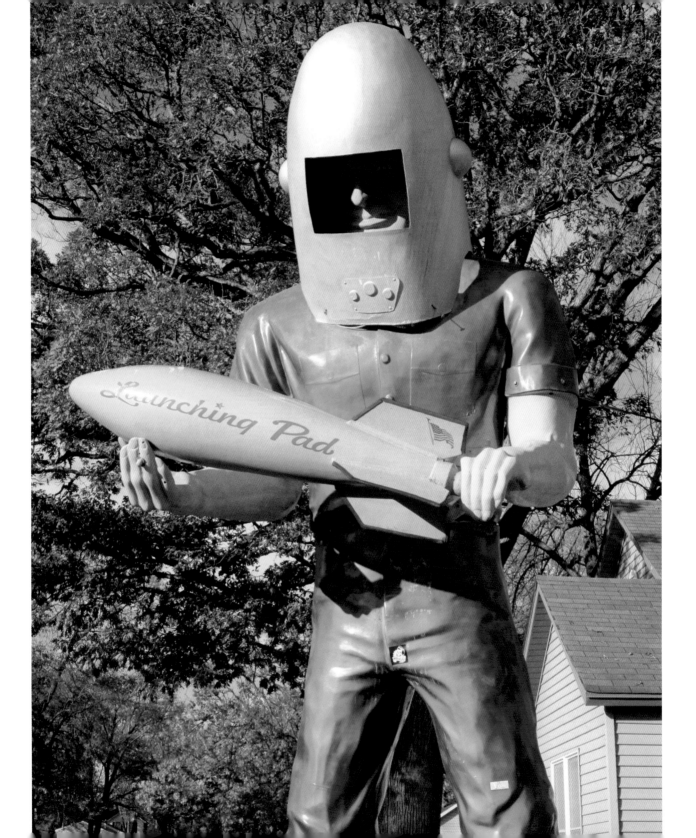

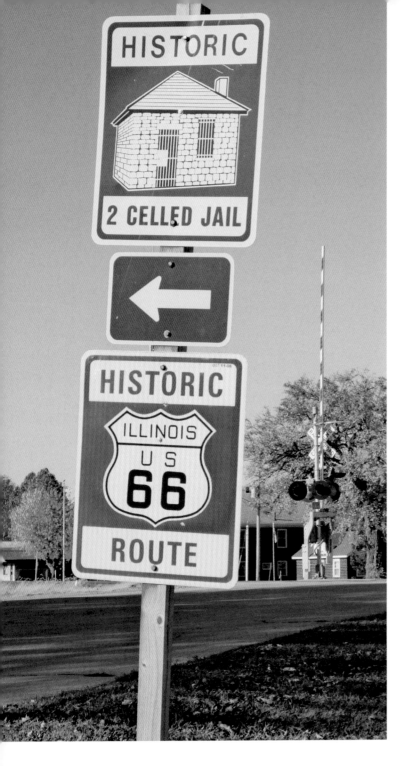

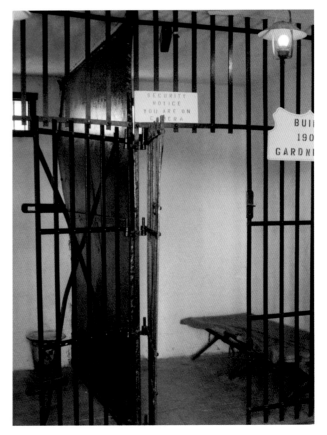

ABOVE
The historic jail in Gardner is one example of an historic site that attracts visitors to a community regardless of size.

LEFT
Recognizing the value of Route 66 as an attraction, the state of Illinois has invested in signage that ensures travelers can follow the course of the highway and find major attractions.

OPPOSITE
Established in 1933, and added to the National Register of Historic Places in 2001, the Ambler/Becker station in Dwight was the longest continuously operated service station on Route 66.

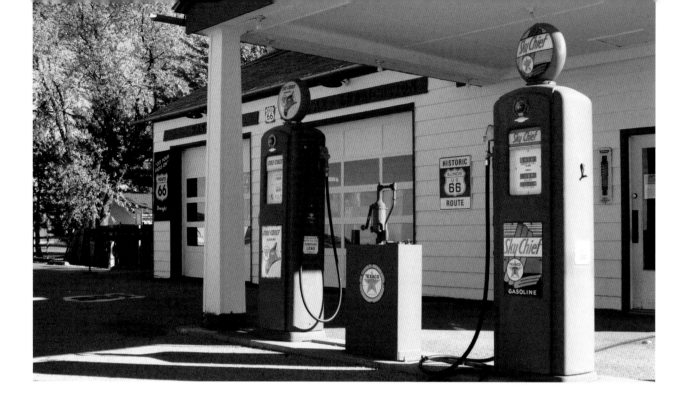

there is increased promotion of Route 66 to the growing number of individuals who tour by bicycle, which has led to the repurposing of some abandoned segments of the highway as bicycle corridors, especially the long-neglected two-lane sections of former four-lane bypass alignments.

Recently, the Adventure Cycling Association released a detailed overview of the entire Route 66 corridor from the perspective of touring by bicycle. This included a GPS-based map series.

The historic district that surrounds the 1891 Chicago & Alton Railroad Depot, still utilized as a depot but that also houses the Dwight Historical Society Museum, presents the impression that time stopped some sixty or seventy years ago. Walking eliminates frustration associated with narrow streets, one-way streets, and parking. It also provides a better opportunity to examine unique architectural details such as those on the façade of the First National Bank Building of Dwight, designed by Frank Lloyd Wright, or the Keeley Institute Building adorned with stained-glass windows designed by Louis J. Millet, a student of Lewis Tiffany.

The Pioneer Gothic Church at 201 North Franklin Street, built in 1858, appears as just another nondescript clapboard church built in the nineteenth century. In actuality, it is a Carpenter Gothic masterpiece listed as one of the "150 Architectural Treasures" in the state of Illinois by the Association of Illinois Architects in 2007. As a historic footnote, during a hunting trip in the area in 1860, Edward, the Prince of Wales (later King Edward VII), attended services here.

Another unique architectural treasure is the Oughton Estate Windmill on the parklike grounds of the Country Mansion Restaurant, 101 West South Street. Built in 1896, the five-story, steel-framed octagonal structure appears to be a cross between a lighthouse and a windmill. Its inclusion in the National Register of Historic Places in 1980 attests to its importance as a unique artifact.

If the era of the Route 66 renaissance had a birthplace in Illinois, it would be Odell, south of Dwight. The 1932 Standard Oil Gasoline Station at the south end of town was one of the first projects initiated by the

Illinois Route 66 Association Preservation Committee. Today, it houses a visitor center and gift shop.

If the Route 66 renaissance has a showpiece that exemplifies the transformative powers of that movement, it would be Pontiac, with the picturesque Livingston County Courthouse built in 1875 casting long shadows over the square and historic business district and colorful murals adding a sense of vibrancy. Spearheaded by intrepid Mayor Bob Russell, innovative cooperative partnerships fostered the development of a sense of community and purpose that manifested in building restoration and renovation, museum establishment, business development, park rehabilitations, and a number of other projects. Today Pontiac is a major destination for Route 66 enthusiasts and is one of the leading tourism destinations in the state of Illinois.

On January 10, 2016, *Route 66 News* published a story noting that the city's tourism director, Ellie Alexander, reported that 2015 was the sixth consecutive year for tourism growth.

Aside from the vibrant and diverse historic business district, Pontiac has an array of stellar attractions, some of which are unique. Three swinging bridges built in 1898, 1926, and 1978 span the Vermilion River and connect parks and green spaces.

The Pontiac-Oakland Museum at 205 North Main Street is the largest collection of those marques of automobile and memorabilia in the world. The complex also houses a full research library of original materials. The Museum of the Gilding Arts, 217 North Mill Street, preserves centuries of gold and silver leaf gilding history.

For Route 66 enthusiasts, the Route 66 Hall of Fame & Museum at 110 West Howard Street is a revered

stop on any Mother Road adventure. Here the home-built bus belonging to iconic folk artist Bob Waldmire is on permanent display and the mural at the rear of the museum has become so famous that it recently graced a *National Geographic* calendar.

Pontiac, however, is not resting on its laurels. As with projects such as color-coded paths to restaurants and museums, and informational banners in several languages, the city continues to be a trendsetter in the utilization of the Route 66 renaissance as a catalyst for development and revitalization.

In discussing future projects, Bob Russell promoted the restoration of the Eagle Theater, a 1930s-era movie theater into a "showcase for Route 66–themed entertainment for visitors."

In the twenty-first century, a living, breathing time capsule is the descriptor for Route 66. A living time capsule filled with time capsules would be a more accurate description. As an example, the Chenoa Pharmacy in Chenoa, south of Pontiac, opened as Schuirman's Drug Store in 1889 and remains as one of the oldest continuously operated pharmacies in the nation. As it retains many of its original fixtures, it is also a museum.

Lexington and Towanda are two more communities that illustrate the potential the resurgent interest in Route 66 has even for the smallest of communities. In the 1940s, the construction of the four-lane bypass alignment in Illinois severed the business district from the economic vitality provided by Route 66. To counter this, the city

Some of the refurbished swinging bridges that connect the riverside parks in Pontiac date to the late nineteenth century.

The Bloomington-Normal metropolitan area has a lengthy and colorful history that predates Route 66. Until quite recently the preservation of landmarks such as the David Davis Museum State Historic Site, the McLean County Museum of History housed in the 1903 courthouse, and other historic sites were the cities' primary focus while Route 66–related sites languished.

In recent years, that focus has changed rather dramatically. In mid-2015, the Cruisin' with Lincoln on 66 Visitor Center opened on the first floor of the McLean County Museum of History, 200 North Main Street. A collaborative effort by local as well as state agencies, the visitor center highlights Abraham Lincoln–associated sites accessed via Route 66.

The Sprague Super Service Station complex that included a café, gas station, garage, and upstairs apartment for the owner manager when the facility opened in 1931, now nominated for inclusion in the National Register of Historic Places, reopened in spring 2016 as a gift shop and visitor center. Terri Ryburn spent ten years renovating the facility, and long-term plans include the addition of a small bed and breakfast and diner.

The drive along Route 66 from Bloomington-Normal to Springfield is relatively short in distance, but not in attractions that preserve the history of Route 66 and the state of Illinois. Here, too, you will find rather dramatic examples of how the resurgent interest in Route 66 is invigorating small, rural communities.

You will also find stunning natural treasures, attractions for a generation of Route 66 enthusiasts who have little or no direct connection to that highway before its decertification. A stellar example is the Sugar Grove Nature Center located a short distance from Funks Grove Store.

The nature center is located in the midst of the largest remaining intact prairie grove in the state of Illinois, more than one thousand acres of old-growth forest, native prairie grasses, and riparian areas. Designated a National Natural Landmark by the US Department of the Interior, the preserve offers miles of trails and a well-maintained historic church and cemetery.

installed a simple neon sign on the new highway with an arrow pointing into town and the word *Lexington*.

Now restored, that simple sign is a favored photo stop for the Route 66 enthusiasts. Its neon casts a glow over two lanes of the former four-lane highway that is now included in the Route 66 Bike Trail. A one-mile (1.6-kilometer) segment of the original highway embraced by cornfields now serves as Memory Lane, a walking or bicycle trail that is a unique attraction. To provide visitors with a sense of time travel, circa-1940s billboards and Burma-Shave signs line the roadside.

A similar project in Towanda utilized a 1.6-mile (2.6-kilometer) segment of the abandoned 1954 alignment. The Geographical Journey Parkway features educational kiosks about each of the eight states that constitute the Route 66 corridor and kiosks with informational flyers printed in numerous languages. Volunteers and students and teachers from the Normal Community High School developed the attraction.

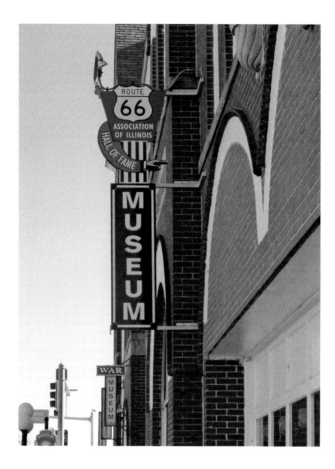

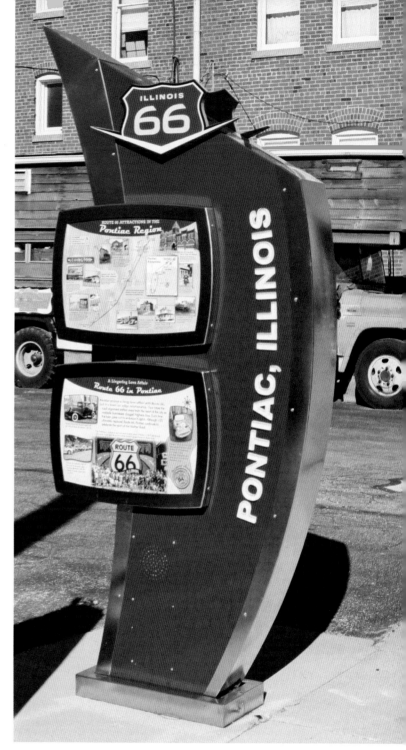

ABOVE
A prized exhibit at the Route 66 Hall of Fame Museum in Pontiac
includes the microbus that served as a traveling studio for iconic
artist Bob Waldmire.

RIGHT
Stylish and informative kiosks—such as this one in Pontiac—
enhance the adventure all along the Route 66 corridor in Illinois.

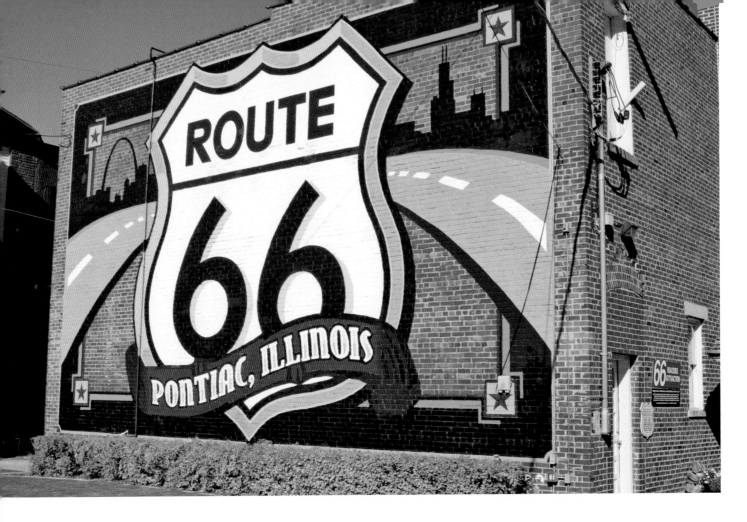

ABOVE
The mural on the rear wall of the Route 66 Hall of Fame Museum in Pontiac is one of the most photographed sites on Route 66.

RIGHT
The refurbished neon sign at Lexington dates to the 1940s, when Route 66 was realigned as a four-lane highway to alleviate traffic congestion in communities.

OPPOSITE
The bucolic nature of the Route 66 corridor in Illinois blurs the line between past and present.

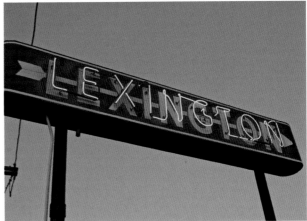

The Funks Grove Pure Maple Sirup Store, Funk Prairie Home, and Funk Gem and Mineral Museum are all attractions of note. The Funk family has produced maple sirup (the original spelling) here since 1824 and sold the product commercially since 1891. Lafayette Funk was the cofounder and director of the Chicago Union Stockyards and an Illinois state senator. His prairie home built in 1864 contains a wide array of intriguing historical artifacts, including one of the earliest electric kitchen islands, still operational.

Diminutive Atlanta, Illinois, just south of McLean, is another shining example of the potential for economic revitalization when a community harnesses the resurgent interest in Route 66 as a catalyst. In a relatively short period, Atlanta has transformed from a picturesque but largely empty community into a thriving destination, largely the result of Bill Thomas's skills as a diplomat, as well as his passion, his vision, his drive, and his ability to inspire. These attributes and the transformation of Atlanta led to his appointment as the chair of the steering committee for the ambitious Route 66: The Road Ahead Initiative initiated by the National Park Service and World Monuments Fund.

In addressing the revitalization of Atlanta, Bill Thomas said, "The majority of the Route 66–related 'successes' we have had in Atlanta, Illinois[,] are, I believe, directly attributable to the steps we have taken over the past several years to carry out what we look upon as the guiding principle of all our efforts. Our focus is to provide visitors with engaging, authentic experiences that do two things. The first of these is to re-create Route 66–related experiences from the past. The second is to develop new and engaging, authentic experiences that are in tune with the idiosyncratic nature of Route 66."

To date, that vision has resulted in the establishment of some rather unique attractions. The Palms Grill Café reopened as a functioning restaurant that, with the exception of prices, almost perfectly presents the illusion that it is a circa-1940s diner.

The historic Colaw Rooming House has opened as a bed and breakfast allowing guests to experience a

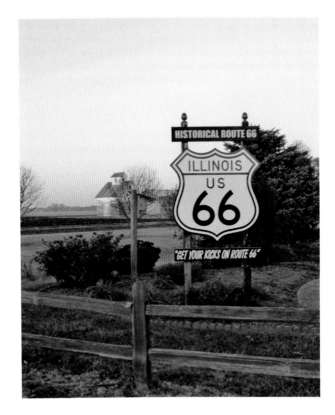

circa-1930s rooming house. Another recent attraction is the Route 66 Arcade Museum featuring several dozen operational pinball and arcade games from the period of 1930 through the early 1980s.

For interactive experiences, the city has been just as innovative. The 1908 Seth Thomas clock in the tower on the grounds of the historic octagonal library needs weekly winding. The installation of a window in the tower door allows visitors to watch the process, and a selected visitor assists in the clock's winding before presentation of a souvenir card that designates them as an honorary Keeper of the Clock.

All of this is set against a backdrop of originality, including a grocery in business for decades and the J. H. Hawes Grain Elevator and Museum. The latter is the state's only fully restored wooden grain elevator,

a uniqueness that warranted inclusion in the National
Register of Historic Places.

Lincoln, the only community named for the
sixteenth president before he took office, is home to
a rather eclectic display of attractions, each of which
illustrates the unique nature of a Route 66 experience in
the twenty-first century.

The red brick Lincoln City Hall, 700 Broadway
Street, built in 1895, is adorned with a phone booth on
the roof, installed so weather spotters could report severe
weather conditions. The Logan County Courthouse built
in 1905 is another architectural masterpiece. The Postville
Courthouse State Historic Site at 914 Fifth Street is an
exact reproduction of the courthouse where Abraham
Lincoln served as a lawyer in the Eighth Judicial Circuit.

There are eleven colorful murals painted by the
Wall Dogs, an organization of artists responsible for the
stunning murals in Pontiac, and a monument that marks
the site where Abraham Lincoln christened the town with
watermelon juice in the summer of 1853. The Lincoln
Heritage Museum at Lincoln College is deemed one of the
thirty most amazing university museums in the world,
largely because of its extensive collection of artifacts
pertaining to Abraham Lincoln.

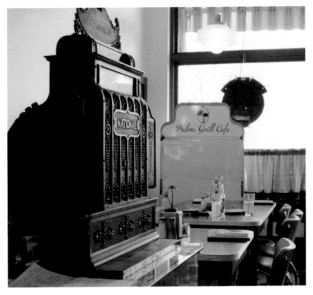

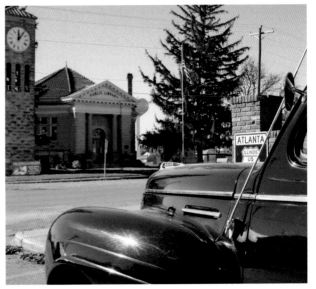

Billed as the "World's Largest Covered Wagon" is another Abraham Lincoln–related site. In 2010, *Reader's Digest* proclaimed the giant wagon with Lincoln in the driver's seat a top roadside attraction.

In Lincoln, the Mill on 66, 738 South Washington, is another manifestation of how the resurgent interest in Route 66 is transforming communities. Initially opened in 1929 as the Blue Mill, the Dutch-styled building—complete with rotating windmill blade—quickly became a favored dining spot for locals and travelers alike. The restaurant closed in 1996 and suffered from neglect and vandalism, but in 2007, a full restoration commenced with much of the work done by volunteers.

One of the more intriguing aspects of Route 66 in the modern era is its international appeal. This is not limited merely to the legion of travelers from Europe, Asia, Australia, and New Zealand who travel the road each year.

A superb example of other ways this is transforming the nature of Route 66—and, as a result, the Route 66 experience—is to be found at Horse Feathers Antiques & Gift Shop and the Wild Hare Café in sleepy little Elkhart. Housed in a century-old bank building with some interesting architectural details, the eclectic little store with the restaurant in the rear and hand-painted murals adorning the walls is unique.

Peter Niehaus, originally from Maastricht, Netherlands, and Andrea Baldwin, whose sister lives in Lincoln, Illinois, relocated from South Africa with an idea to start a business. Baldwin said, "I wanted quaintness, Old-World charm, an old building, and a pretty setting to create the right ambiance. After looking at many places my sister mentioned Elkhart so we drove over, had a look, and it was perfect."

Unfortunately, there were no buildings available in the one-block business district of century-old red brick buildings. "When one finally came on the market, we bought it immediately and began renovations, which took almost two years. As it happens, this is my husband Peter's specialty so he was in his element," Baldwin says.

Restored molding and woodwork attests to Peter's skills. Likewise with the towering bookcases and

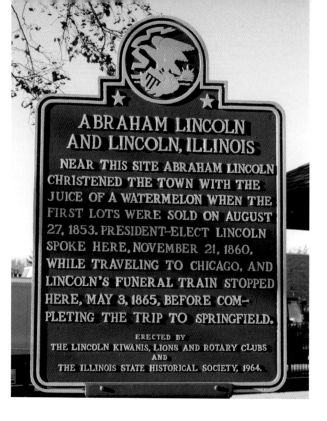

ABOVE

All along the Route 66 corridor in Illinois, historic markers commemorate a community or site's association with Abraham Lincoln. Legend has it that Abraham Lincoln christened the town site of Lincoln with the juice of a watermelon. This is the only community named for Lincoln before he became president.

OPPOSITE TOP

The Palms Grill Café in Atlanta is a shining example of how harnessing the resurgent in Route 66 can serve as a catalyst for economic development.

OPPOSITE LEFT

The historic detail in the refurbishment of the Palms Grill Café in Atlanta is another example of why Route 66 is referred to as a living, breathing time capsule.

OPPOSITE RIGHT

With Bill Thomas's vintage Plymouth as a prop, discerning the date becomes difficult on the main street in Atlanta.

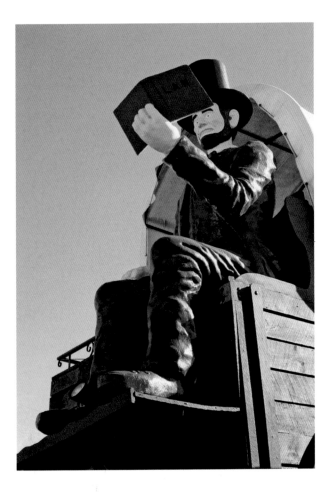

picturesque setting, which is so appealing to tourists. We have tourists coming here from all over the world and I think the reason they find Elkhart so appealing is because it epitomizes small-town America in their minds; a quaint little village."

When asked about Route 66 in the twenty-first century, Baldwin said, "As far as the future of Route 66 is concerned, I don't think it will ever lose its appeal for the reasons I have mentioned. If anything it will gain in appeal as other countries, as well as areas in our own country, become more overpopulated and built up."

Springfield is at the heart of the state tourism office's "Cruising with Lincoln on 66" marketing campaign as there are a number of iconic Route 66 sites and numerous historic sites that provide for intimate insight into the nation's sixteenth president. In addition, one of the largest Route 66–themed events, the International Route 66 Mother Road Festival, takes place in this city on the last full weekend of each September.

The Abraham Lincoln Presidential Library & Museum at 112–212 North Sixth Street, an alignment of Route 66, blends high-tech interactive exhibits, multimedia programs, interactive displays, and the largest existent collection of documentary material into an experience that provides an immersion into the world of Abraham Lincoln.

A few blocks away, 426 South Seventh Street is the Lincoln Home National Historic Site. Preserved as it appeared in 1860 is the home of Abraham Lincoln and the surrounding neighborhood. Free tickets are available at the Lincoln Home Visitor Center.

The president's tomb and monument is located at 1500 Monument Avenue. Lincoln's law office at 112 North Sixth Street, the depot at 930 East Monroe Street, and the Old State Capitol State Historic Site are other Abraham Lincoln–associated sites that should be included in a Springfield visit.

The city has a number of Route 66–associated sites; some have a historic association and others are products of the highway's renaissance era. None, however, has the stature of the Cozy Dog Drive In.

bookshelves, restored after their rescue from an old school in Lincoln during its demolition.

An intriguing and pleasant ambiance, excellent food prepared from scratch using locally grown produce at reasonable prices, amicable proprietors, and a smiling, professional staff ensure a stop at the Wild Hare Café will be a memorable one. As Baldwin noted, "But the most important factor to the success of the business has been its superb location on Route 66. Elkhart is virtually in the center of the state, right on Route 66, with its Old-World charm, and

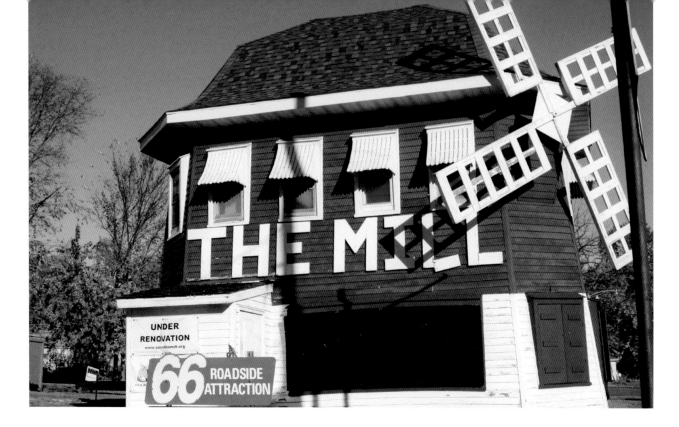

The revived interest in Route 66 has led to the preservation of numerous historic buildings in Lincoln, including The Mill, a restaurant that dates to the 1930s.

The Wild Hare Café and Horse Feathers, an eclectic antique shop housed in a former bank, dominate the diminutive historic business district in Elkhart.

Statues, quirky attractions, monuments, and historic sites associated with Abraham Lincoln abound along the Route 66 corridor in Illinois.

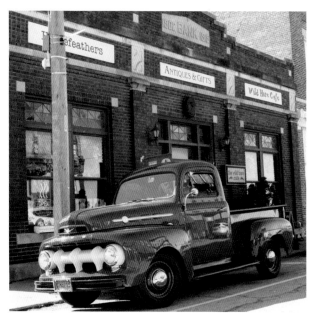

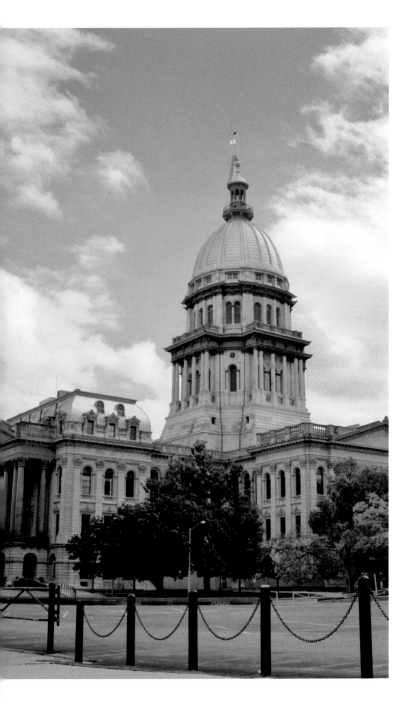

Even though the current manifestation of the restaurant dates to 1996, the origins for this drive-in are in the creation of the cozy (corn) dog itself. Buz Waldmire, son of founder Edwin "Ed" Waldmire, said, "My dad stopped at a roadside restaurant in Amarillo, Texas, during World War II. They had corn dogs on the menu, but it took twenty minutes to get one because they baked them in an oven. Restaurants across the country were developing similar versions."

Working with a former college roommate whose father owned a bakery, a batter that would stick to a hot dog for frying in oil was concocted. Ed Waldmire, stationed at the Amarillo Army Airfield, began selling the "Crusty Curs" at the base PX, and on weekends to diners and cafés along Route 66 in the Texas Panhandle.

After the war, he returned to Illinois and sold his creation in 1946 at the state fair in Springfield. The popularity of his creation led him to open a small stand at Lake Springfield Beach, and with a bit of creative input from his wife Virginia, they were renamed Cozy Dogs. In the early 1950s Waldmire had three locations in the city before deciding to concentrate operations at one location on Route 66.

The food and the signature trademark of two hot dogs bound in a loving embrace are part of the allure for Route 66 enthusiasts. Ed and Virginia Waldmire's son

LEFT
The historic capital building in Springfield, built in 1888, was the backdrop for Senator Barack Obama's initial presidential candidacy announcement.

OPPOSITE TOP
The menu, as with the restaurant itself, is unique and simple at the Wild Hare Café.

OPPOSITE BOTTOM
The Cozy Dog Drive In, established in 1949 by Edwin Waldmire, father of artist Bob Waldmire, is a favored destination in Springfield for Route 66 enthusiasts.

Bob is an icon who played a crucial role in the launching of the highway's renaissance. His unique artwork in the form of postcards, murals, and posters are recognized throughout the world. His customized school bus converted into a motor home and art studio is a major attraction at the museum in Pontiac, and there is even an association with the animated film *Cars* as Bob Waldmire served as the inspiration for the character Fillmore.

From Springfield to the Mississippi River, Route 66 followed a number of different courses. However, with the exception of Litchfield and Mount Olive, it is the earliest alignments of State Highway 4, all of which were the path of Route 66, that most appeal to the interests of Route 66 enthusiasts today.

Illinois was a pioneer in highway development, and in 1926 when the course for newly certified US 66 shared that of State Highway 4, it became the only fully paved statewide section of Route 66. Preserved along this segment of the road are links to decades of highway engineering improvements. Moreover, as the towns along this corridor have a rather lengthy and colorful history, they add vibrancy to the drive.

A superb example of these engineering remnants is located on Snell and Curan Roads immediately to the north of Auburn. A sixteen-foot-wide (five-meter-wide) segment of Portland cement roadway dates to the initial paving of State Highway 4 in 1921. Then there is a 1.5-mile (2.4-kilometer) section of this roadway overlaid with handset red bricks in 1932. Also on this segment of early highway are two single-span concrete bridges built in 1920. This section of roadway is so unique that it warranted inclusion in the National Register of Historic Places.

Each of the communities along this section of the road offer special places, fascinating attractions, interesting restaurants and cafés, and obscure historic sites. However, Carlinville is truly the crown jewel.

Listed on the National Register of Historic Places, the Carlinville Square features an array of architectural styles ranging from the mid- to late-nineteenth century and the early twentieth century. Built in 1869 in the

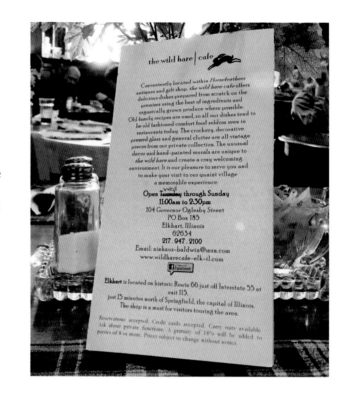

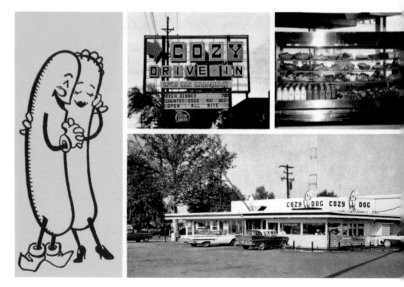

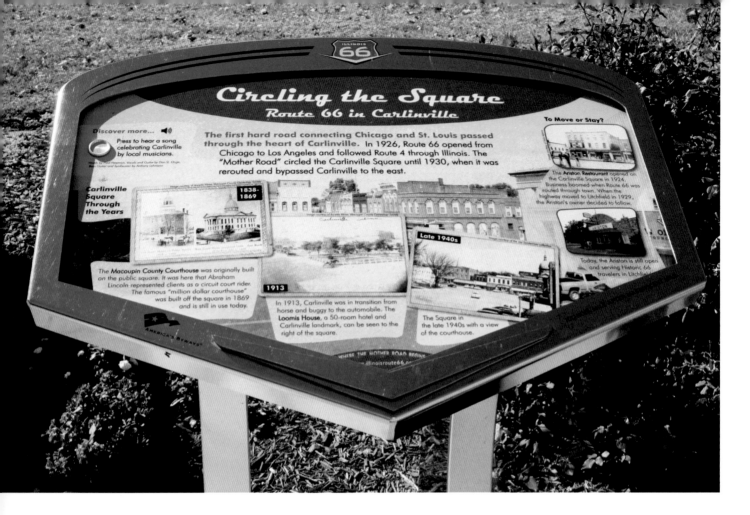

ABOVE
Colorful and informative kiosks along the Route 66 corridor in Illinois enhance the adventure, as well as provide interesting photo opportunities.

OPPOSITE TOP
Listed on the National Register of Historic Places is this section of hand-laid brick roadway near Auburn that served as the initial alignment of Route 66.

OPPOSITE BOTTOM
Dubbed the "million-dollar courthouse," the courthouse in Carlinville is a monument to the high cost of political corruption, graft, and cronyism.

Gothic Revival style, the imposing stone jail is another architectural treasure.

The Macoupin County Courthouse, deemed the most magnificent historic courthouse in the state, is a monument to cronyism and political corruption on an epic scale. Commissioned in 1867, and designed by architect E. E. Myers, the proposed budget was $50,000. By 1870, with the incomplete building already the second largest courthouse in the nation and expenses nearing $1.3 million, the county suspended construction. It took the county more than four decades to pay off the incurred debt.

Not all of the architectural treasures in Carlinville are of such monumental scale. In the neighborhood of Charles and Rice Streets stands the largest collection of

Sears & Roebuck mailorder houses in the United States. Built by the Standard Oil Company for mineworkers in 1918, 152 of the original 156 homes remain in a district referred to as the Standard Addition. For the Route 66 enthusiast is a period-correct motel, the Carlin Villa that provides a bit of the atmosphere circa 1960.

On the post-1930 alignment in Litchfield is a very special little gem that is a link to the entire evolution of Route 66. The Ariston Café also exemplifies the nature of the modern Route 66 community.

"My father, Pete, opened the Ariston Café in Carlinville in 1924. With the rerouting of Route 66, the hard road, from Highway 4, he opened a second location in Litchfield in 1930," Nick Adam said. "That second restaurant was across the street from the current location that opened in 1935."

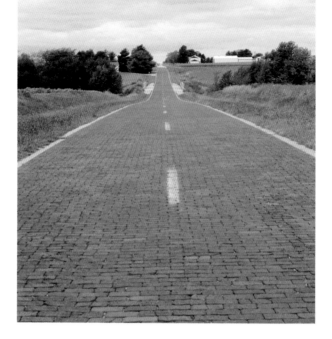

Pete Adam arrived in the United States from Greece thanks to the generosity of a sponsor in St. Louis. The fifteen-year-old immigrant spoke almost no English, and before opening his restaurant in Carlinville, he earned a living by shining shoes in Baltimore and working for the Rock Island Railroad, as well as at a sheep ranch in New Mexico and at a mine in Pueblo, Colorado. During World War I, he returned to Greece and fought in the Greek army.

With fellow Greek immigrant Tom Cokinos as his partner, Pete Adam first delved into the restaurant business by opening a candy kitchen. Cokinos had learned the art of candy making in St. Louis. Adam's second endeavor speaks volumes about his character.

Nick Adam said, "A doctor loaned my father two thousand dollars to open a restaurant in Carlinville. He purchased restaurant equipment in St. Louis and hired a cook from there as well."

Contractor Henry A. Vasel built the current restaurant for a cost of $4,771.00. It opened for business on July 5, 1935, with a two-pump gasoline station out front to attract additional customers. In 1940, Pete Adam added colorful neon signage to the rear of the restaurant to ensure that business remained brisk even though another rerouting transformed Route 66 into a four-lane highway at the rear of the property.

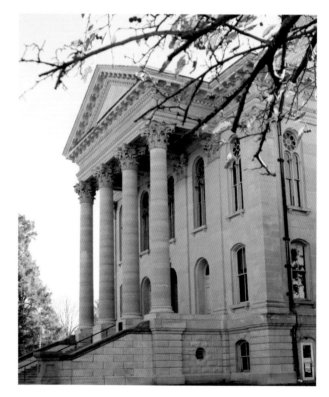

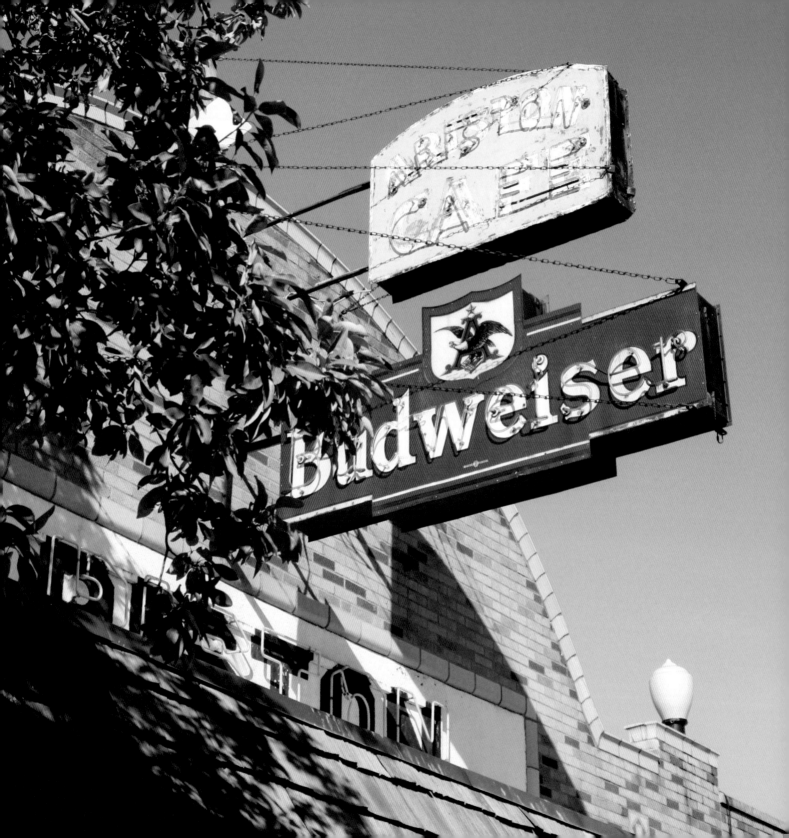

In December 1965, Pete Adam's son Nick returned home to Litchfield from Pittsburgh. After discussions with his father, Nick Adam and his wife, Demi, began managing the restaurant after January of the following year.

"We planned on running the restaurant for a couple of years and then selling it," Nick Adam said. "That was fifty years ago."

When asked about the popularity of Route 66, Adam said, "In 2014, visitors from forty-three countries signed the guestbook; this year we have thirty-eight countries represented."

Listed on the National Register of Historic Places in 2006, the Ariston Café is a throwback to another time when linen tablecloths, freshly prepared meals, and attention to the smallest of details by the owners who greet each customer with a smile were the norm, not the exception, at cafés all along Route 66.

Paul Adam, the oldest son of Nick and Demi, and his wife, Joy, joined the family business in 2004. Times, however, change, and the end of an era is near as the family is discussing the sale of the restaurant.

The various alignments of Route 66 merge near Staunton, pass through towns such as Edwardsville that hosted the Miles of Possibilities conference and related Route 66 festivities in 2015, and then flow into East St. Louis before again branching into a number of Mississippi River crossings.

In 1926, Illinois proudly proclaimed that they were the only state in which Route 66 was paved end to end. In 1940, the state transformed Route 66 into a four-lane, limited-access highway. In the modern era, the state has pioneered the transformation of Route 66 through community partnerships, creating bicycle corridors from abandoned alignments and installing electric vehicle–charging stations.

OPPOSITE

The Ariston Café in Litchfield is another example of the living time capsules found along the Route 66 corridor between Chicago and Santa Monica.

ABOVE

In Edwardsville, as in other communities along the Route 66 corridor in Illinois, the historic highway courses through shaded dappled neighborhoods and business districts unchanged in decades.

BELOW

Author Jim Hinckley visits with Nick Adam, son of Pete Adam, who founded the Ariston Café in 1924.

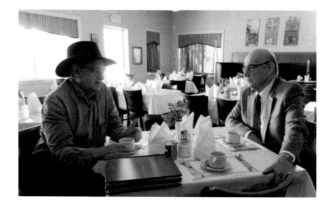

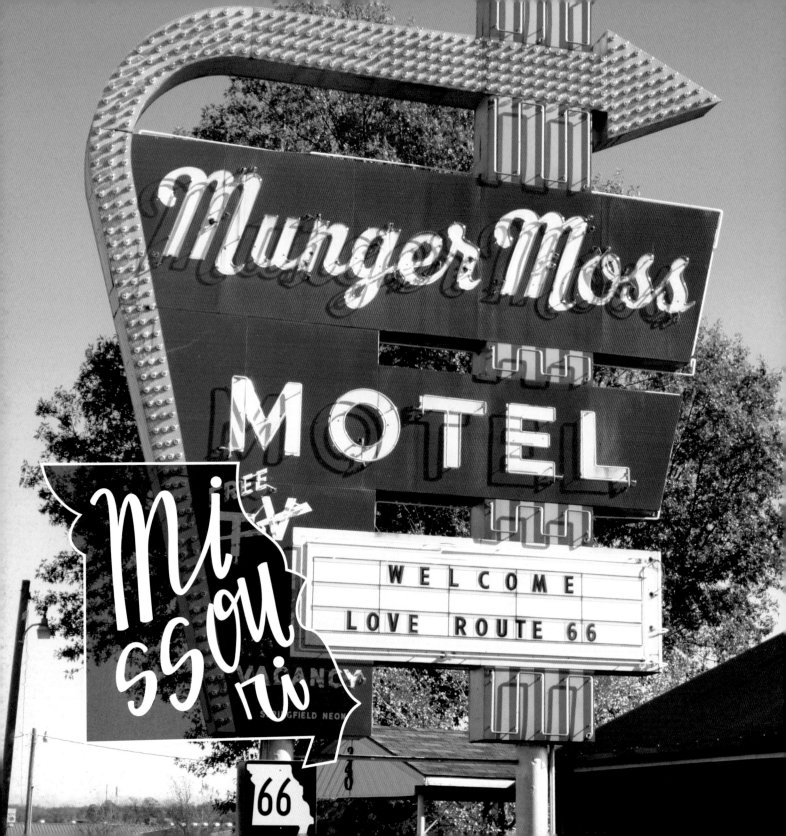

THE LAND OF THE OZARKS

All of the metropolitan areas along the Route 66 corridor get short shrift when it comes to the Route 66 renaissance. However, in regards to Route 66 exploration, or utilizing the resurgent interest in Route 66 as a catalyst for revitalization, St. Louis and East St. Louis may top the list.

Here, the problems associated with traffic congestion or getting lost are compounded rather dramatically as Route 66 follows a number of different courses across the Mississippi River and through the cities. Additionally, in some areas, such as in East St. Louis, there are serious safety concerns associated with getting lost.

Jerry McClanahan succinctly describes the problems about following Route 66 through St. Louis in his stellar work, *EZ 66 Guide for Travelers.* "A profusion of short lived 'optional,' 'city,' and 'truck' routes add to the confusion created by cut streets and a one-way section as older 66 zigs up to McKinley Bridge." Added to this is a seemingly endless series of news stories about the violence under banner headlines that proclaim, "St. Louis Ranked the 4th Most Dangerous City in America, Again" or "East St. Louis Ranked Most Dangerous City in the Country." Is it any wonder that many Route 66 enthusiasts take in the world-famous Gateway Arch, stop at Ted Drewes, and then hit the road out of town?

However, for those who do take a bit of time for exploration, there is ample reward in a multitude of fascinating historic sites, architectural masterpieces, scenic wonders, and superb restaurants. It begins with

ABOVE

Of the various bridges used as Mississippi River crossings for Route 66, the Chain of Rocks Bridge, with its quirky mid-river bend, is one of the most famous today.

OPPOSITE

The Munger Moss in Lebanon, Missouri, with its classic neon sign, is an icon in the era of renaissance.

ABOVE

Vestiges from the Route 66 corridor in the St. Louis area are found in surprising locations. These signs are at Henry's Rabbit Ranch in Staunton, Illinois.

OPPOSITE TOP

The Eads Bridge officially opened on July 4, 1874. It was the first use of structural alloy steel in a bridge project and the largest arch bridge ever constructed.

OPPOSITE BOTTOM

Horse-drawn carriage rides in the shade of the Gateway Arch enhance the historic feel of a visit to the Laclede Landing area of St. Louis.

The northernmost crossing is the Chain of Rocks Bridge built in 1929 with a unique twenty-two–degree turn at midstream. Engineers routed a bypass alignment across the bridge in 1936, and abandonment of the structure occurred in 1968. Today the bridge is festooned with an array of vintage Route 66 signage and artistic touches, such as Route 66 shield benches, and serves as the river crossing for Trailnet, a series of Missouri bicycle paths and pedestrian walkways linked to similar trails in Illinois.

Guidebooks strongly suggest parking on the Illinois side of the bridge before setting out on a stroll across the river. This is another indication of the struggles that metropolitan areas are facing in regards to enticing Route 66 enthusiasts to spend more time in their communities.

The McKinley Bridge, named for Congressman William B. McKinley, dates to 1910. It served as the initial river crossing for Route 66 in 1926 and in 2007 reopened after a six-year renovation that included the addition of bicycle and pedestrian paths.

The MacArthur Bridge, once known as the Municipal Bridge and renamed in honor of General Douglas MacArthur in 1942, dates to 1916. In addition to being the first toll-free bridge across the Mississippi in the area, it served as the primary river crossing for Route 66 from 1929 to 1935 and carried City 66 traffic until 1955. Renovations and upgrades transformed the structure into a rail bridge after removal of the auto deck.

The Veterans Memorial Bridge, renamed the Martin Luther King Bridge in 1972, carried Route 66 traffic from 1955 to 1967. The Bernard Dickman Bridge, now utilized by Interstate 55, Interstate 70, and Interstate 64, served as the river crossing for Route 66 until November 9, 1967.

The nearby Gateway Arch overshadows the Eads Bridge and the surrounding Laclede's Landing District. However, this is the historic heart of the city and should be included as a destination.

Even though the Eads Bridge never carried Route 66 traffic, it is a historic structure of note. It opened as the longest arch bridge ever constructed to date on July 4, 1874. It is also the first bridge built from structural steel alloy.

Peppered with interesting and eclectic restaurants and shops, Laclede's Landing District that surrounds the west end of the bridge contains a staggering array of historically significant and architecturally unique buildings, many of which date to the mid- to late-nineteenth century and that are listed on the National Register of Historic Places.

The oldest of these is the Schellhorn-Albrecht buildings, 719 to 727 North First Street, which date to at least 1844. At 214 Morgan Street stands the Morgan Landing Building built in 1905; a saloon has operated at this location for more than 130 years. Other structures of note in this district include the First Street Ironworks,

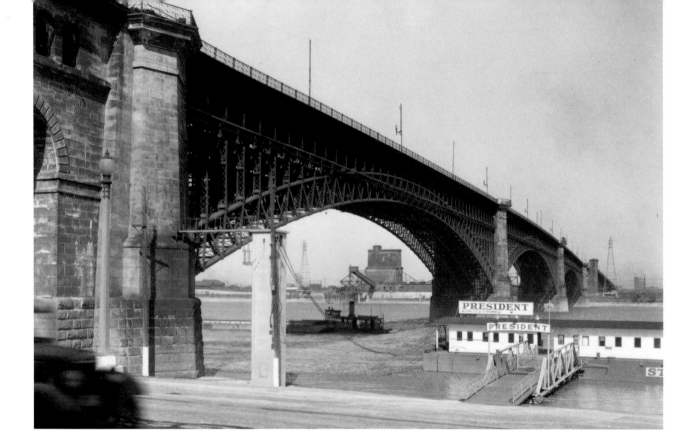

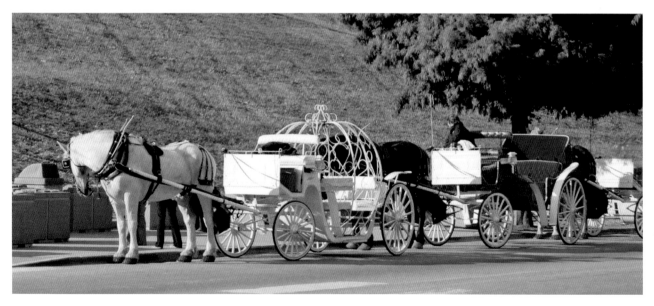

43

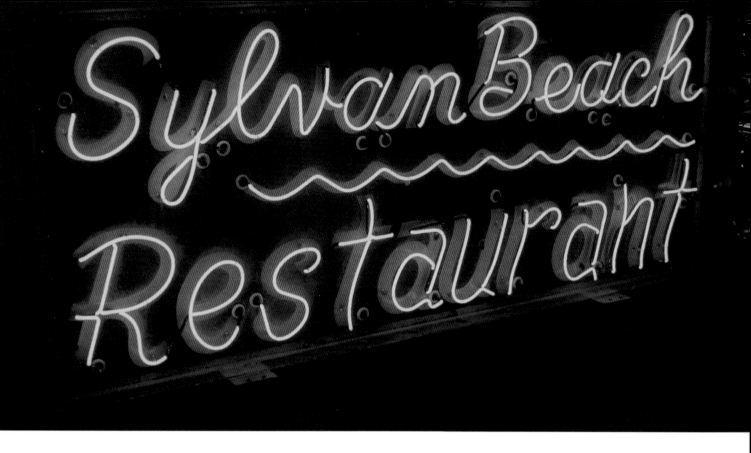

720 to 722 North First Street, built in 1881; the Feather Building, 1882; and the Cast Iron Building, 1873.

The Hoffman Brothers Produce Building at 700 North Second Street has a Hollywood connection. Actress Betty Grable worked at her grandparents' produce market in this historic building that dates to 1883.

Laclede's Landing District is only one of the historically and culturally rich areas of St. Louis often overlooked by enthusiasts traveling west on Route 66. Another would be Forest Park bordered on the south by Forest Park Avenue and Clayton Street, the course for Route 66 in 1926.

Established on June 24, 1876, Forest Park is one of the largest urban parks in the United States. In preparation for the 1904 Louisiana Purchase Exposition, the St. Louis World's Fair, and the 1904 Summer Olympics, the park underwent a dramatic transformation. Many of the parks facilities and buildings such as the

St. Louis Art Museum and the Missouri History Museum date to this period, as do some of the buildings utilized by the St. Louis Zoo.

The park is a cultural hub for the city of St. Louis. Hosted in Forest Park are annual Shakespeare festivals, music festivals, wine festivals, beer heritage festivals, and art festivals. In September, the St. Louis Symphony Orchestra offers a free outdoor concert on Art Hill.

Today, Forest Park attracts an estimated 12 million visitors annually, surpassing the number of visitors to Jefferson National Expansion Memorial, the legendary St. Louis arch, and Busch Stadium. However, a recent study indicated that 30 percent of those visitors lived within ten miles (16 kilometers) of the park, and another 30 percent lived within thirty miles (48 kilometers).

Before leaving the St. Louis metropolitan area, another attraction of note, one that has a number of Route 66 connections, is the Museum of Transportation

located at 3015 Barrett Station Road in Kirkwood. It is home to a sizable collection of vintage cars, including historic vehicles manufactured in St. Louis, locomotives, railroad equipment, airplanes, and boats that John H. White, curator emeritus of the Smithsonian Institution, described as "one of the largest and best collections of transportation vehicles in the world." A complete bungalow from the legendary Coral Court Motel also stands nearby.

Razed in 1995, the Coral Court Motel figured prominently in the early preservationist movement that was a crucial component in the Route 66 renaissance. Built in 1941, the uniquely styled motel also had historical significance as it is linked to the kidnapping and murder of six-year-old Bobby Greanlease in the fall of 1953.

Valiant efforts to preserve the art deco masterpiece propelled photographer Shellee Graham into the national spotlight as she meticulously documented the architectural attributes of the facility. These photographs were instrumental in the re-creation of the bungalow at the museum built from salvaged materials.

Even though suburban sprawl west of St. Louis has dramatically altered the roadside, both incarnations of Route 66, the pre-1932 alignment now signed as State Highway 100 and the post-1932 alignment decimated by the construction of I-44, are still amply sprinkled with vestiges from a time when the double six was the Main Street of America. However, one quite interesting place has an association with the history of Route 66 since 1932, and that exemplifies the challenges associated with preserving the idiosyncratic nature of Route 66 and ensuring its relevancy in the modern era.

To the east of Eureka and housed in the former Bridgehead Inn, a roadhouse that dates to about 1935, is the headquarters and museum for Route 66 State Park. The park itself is a masterpiece of land reclamation. It is also an example of how a lack of understanding at the state and federal level of government about the international interest in Route 66 can result in the irreplaceable loss of the road's historic infrastructure.

Much of the park, now a wooded refuge for wildlife along the banks of the Meramec River, was

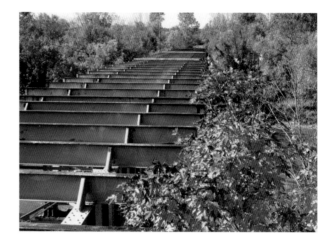

an environmental disaster area of epic proportions in the 1980s and once was the site of an idyllic resort community in the 1930s.

In 1925, the owners of the *St. Louis Star Times* devised an innovative promotional campaign that centered on the purchase of 480 acres along the Meramec River seventeen miles (27 kilometers) west of St. Louis. For the sum of $67.50, a customer could purchase 20-by-100-foot (186-meter squared) lot for the construction of a summer cottage at Times Beach and receive a six-month subscription to the newspaper.

With the rerouting of Route 66 through the community in 1932, an influx of full-time residents as well as businesses changed the very nature of the little town. By 1970, with a population near 1,200 people, the

city government charted a course that would erase the image that this was a low-income community.

The first order of business was to resolve the matter of dirt streets by contracting with Russell Bliss to have them oiled on a regular basis. Unknown at the time was the fact that his cartage company that specialized in the hauling of waste oils and similar materials also had a contract with the Northeastern Pharmaceutical and Chemical Company, a manufacturer of Agent Orange; the oils he sprayed on the streets of Times Beach contained deadly dioxins.

In 1982, after an investigative reporter linked Bliss's company with the death of horses at a stable where he had sprayed oil to control flies, the Environmental Protection Agency initiated an investigation. A severe flood that led to the evacuation of almost the entire community occurred on December 5 of that year, and eighteen days

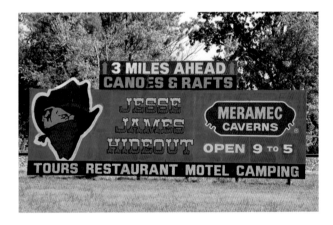

later, the Environmental Protection Agency notified the city management that evacuation of the entire town due to dioxin contamination should begin immediately.

By 1985, the evacuation was complete, negotiated buyouts were well underway, and the entire site was declared off-limits. During the mid-1990s, an incinerator built on site burned hundreds of tons of contaminated soils and materials. Upon certification that the site was clean, the state of Missouri initiated an ambitious land reclamation project that resulted in the creation of Route 66 State Park in 1999.

The park stretched along both banks of the Meramec River with the historic Bridgehead Inn now serving as the visitor center. Linking the two halves of the park was the Meramec River Bridge that had carried Route 66 traffic since 1932.

The bridge provided access to both sides of the park until 2009 when the Missouri Department of Transportation deemed it unsafe for motor vehicles. Even though it received inclusion in the National Register of Historic Places in the same year, the state initiated partial demolition by removing the roadway deck in spite of contentious meetings and valiant attempts by preservationists to have the bridge utilized as part of a bicycle corridor.

In the Route 66 community, the bridge now symbolizes the need to educate government officials at all levels about the importance of preserving historic highway infrastructure. In this instance, as a result of the deck removal, accessing the halves of the park requires a drive of more than ten miles (16 kilometers), and the further development of old alignments of Route 66 as a continuous bicycle corridor were jeopardized.

Near Eureka, it is again possible to leave the interstate highway and follow Route 66 as it follows the contours of the rolling Ozark Mountain countryside. Enhancing the essence of the Route 66 experience in this part of Missouri are the quiet towns and villages, some of which have embraced the resurgent interest in Route 66 with rather dramatic results, and classic roadside attractions.

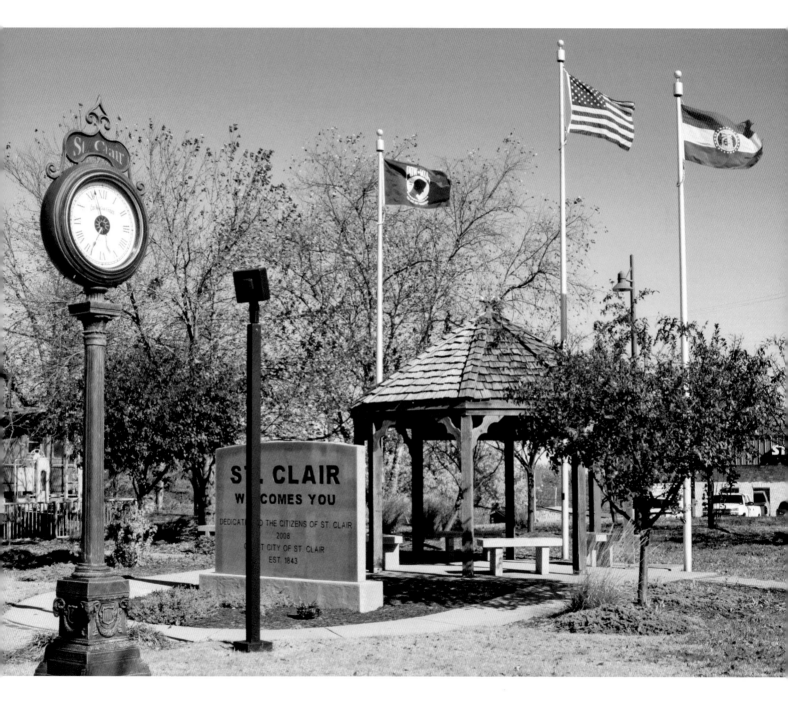

THE LAND OF THE OZARKS

CHAPTER TWO

A superb example is St. Clair. Here, a charming park with memorials, gazebo, and vintage clock front a row of historic buildings, one of which houses the Lewis Café. This venerable institution has been providing locals and travelers on Route 66 with hearty meals since 1938.

Immediately to the west, near Stanton, Meramec Caverns on the banks of the Meramec River blends natural wonder, a bit of history, and a great deal of P. T. Barnum–worthy creative marketing into a charming roadside attraction similar to what was once found all along Route 66.

Jacques Renault became the first European explorer to discover the caverns in 1720. For more than 150 years, the mining of rich deposits of saltpeter found within the caverns, a primary component in the manufacture of gunpowder, ensured that cavern owners prospered and that the property was a point of contention during times of hostilities.

By the dawning of the twentieth century, known then as Salt Peter Cave, the caverns had become a popular area attraction with the installation of a wooden dance floor and a bar in the former saltpeter mine. In the summer of 1901, the discovery of new levels within the caverns added to its popularity.

Lester Dill who acquired the caverns property in the spring of 1933 was well versed in the art of selling the sizzle, not the steak type, of promotion needed to transform the caverns into a major attraction. At ten years of age he had led thrill-seeking vacationers from St. Louis through Fisher's Cave and later turned the caverns into a major attraction after fabricating a story based on a single square nail found within.

The first order of business was changing the name to Meramec Caverns. The second was the construction of a road to connect the caverns with nearby Route 66, and

then the transformation of a portion of the former saltpeter mine into the "World's First Drive In Cave" promoted by his children who fastened bumper signs by wire on every car that stopped. For further assurance that travelers on Route 66 knew of the caverns, Dill began mimicking the famous Rock City advertising campaign and soon barns from Illinois to Oklahoma sported "See Meramec Caverns" advertisements on highway-facing walls.

After World War II, as fear of a nuclear holocaust escalated, Dill stocked a section of the caverns with supplies and marketed the caverns as the "World's First Atomic Refuge." Visitors who paid to see a "modern Noah's Ark" received a card indicating that the holder had a reserved space in the shelter if a nuclear attack occurred.

In December 1941, Dill, professor of geology J. Harlen Bretz, and students from the University of Chicago drained water from a pond in the caverns and discovered an underground river passage. Shortly afterward, Dill announced the discovery of relics that included a strong box, all items that he claimed could be directly linked to Jesse James. Even though there was the faintest trace of credibility in the story since a persistent local rumor claimed that Jesse James, his brother Frank, and members of the infamous Quantrill's Raiders had destroyed the saltpeter operation in the caverns during the Civil War, the discovery garnered little media attention.

In 1949, Dill, working with his son-in-law Rudy Turilli, dusted off the story and added a new twist. In Lawton, Oklahoma, an elderly man named J. Frank Dalton claimed to be both one hundred years old and to be Jesse James living under a false identity. Dill relocated Dalton to the caverns property solely to spin tall tales for tourists and then rebuilt "Jesse James hideout," an old log cabin, within the caverns.

In the early 1960s, Dill initiated his most ambitious marketing campaign. It began with solicitation for a newlywed couple that would live as cave dwellers within a side room of the caverns for ten days while searching for a key. If they found the hidden key, a honeymoon trip to the Bahamas was Dill's gift to them.

OPPOSITE

Capitalizing on the discovery of rusty guns and a metal box in the caverns, an ancient log cabin and neon signage were added to fuel the legend of a Jesse James connection.

For ten days, a couple dressed in leopard skins acted out humiliating skits for each cave tour. For ten days, the publicity built and the cavern's dwelling couple appeared on Art Linkletter's TV show. On the tenth day, the couple found the hidden key that Dill had placed in the cave that morning. As promised, they honeymooned in the Bahamas at Dill's expense.

Today, Jesse James's cabin remains, complete with neon banner. So does the stunning natural beauty of the caverns and the Meramec River. The addition of a zip line and expansion of the gift shop and restaurant are a few concessions to the modern era. Meramec Caverns, however, remains as it has for decades, a classic roadside attraction and another Route 66 time capsule. A short distance to the west, just past the picturesque Belmont Vineyards, home of Brix on 66 restaurant and delicious pink dogwood wine, is the charming community of Cuba, a shining star in the era of renewed interest in Route 66.

From Missouri Hick Barbeque to the renovated historic Wagon Wheel Motel, from Shelly's Route 66 Café to the Hayes Family Shoe Store that has served the town for decades, there is ample evidence of pride

ABOVE
Belmont Winery at Leasburg represents a new generation of attractions along the Route 66 corridor in the Ozarks of Missouri.

RIGHT
Dating to the 1930s, the Wagon Wheel Motel is a favored stop for Route 66 enthusiasts and a symbol of the preservationist movement that is transforming the Route 66 corridor.

OPPOSITE
Colorful murals depicting the area's rich history serve as the cornerstone for the transformation of the quaint village of Cuba into a destination.

BATTLE OF THE HUZZAH SEPTEMBER 29, 1864

CONFEDERATES IN CUBA SEPTEMBER 29, 1864

ABOVE

Cuba Fest, held on the third weekend in October, exemplifies
the charming, small-town festivals that provide the authentic
American experience treasured by Route 66 enthusiasts.

LEFT

Refurbishment of the Wagon Wheel Motel by Connie Echols
has contributed to the transformation of Cuba and
encouraged many communities to view historic
Route 66 properties as valued assets.

OPPOSITE

Fanning today is less than a wide spot in the road but still boasts
the world's largest rocking chair. With that and the unique
Fanning General Store, it still is a Route 66 destination
for enthusiasts today.

in community and pride of community association with Route 66 in Cuba. Colorful murals that are like snapshots from the city's history have earned Cuba the Route 66 Mural City designation, and events such as Cuba Fest held on the third weekend of October enhance the sense that this is a living Norman Rockwell print.

Jill Barnett, the Viva Cuba Mural Chairman, noted how utilizing the resurgent interest in Route 66 as a catalyst for development has benefited the city. Barnett said, "A community block grant was received in the early 2000s, with $237,000 pledged by property owners, which was matched by the state to be used for the revitalization of the uptown district. In 2001, Viva Cuba, starting with an idea from People's Bank, started our mural project. The goal was to complete twelve murals by 2007, the Cuba sesquicentennial."

Barnett added, "This transformed ugly walls into public art and gave people a reason to come to Cuba. During the tourism season, there are many, many visitors stopping to take pictures of our murals. We give guided mural tours, and many large tour buses can be seen maneuvering our small streets. It's amazing the interest!"

The city has not myopically focused on Route 66; it has merely utilized the interest in the highway as a cornerstone for development. The creation of an enterprise zone that allowed businesses to receive tax benefits led to the creation of approximately one thousand jobs. A multifaceted Ozark legacy project that will share the history of American Indians along Route 66 in Missouri is now under development.

The Wagon Wheel Motel, lovingly renovated by Connie Echols and her sister Riva, is a destination unto itself. Established in 1934 as Wagon Wheel Cabins, the original ten-unit complex built by Leo Friesenhan, a stonemason, evolved into a fourteen-unit motel by 1946. A restaurant, now Connie's Shoppe, and a service station ensured that this was a profitable enterprise.

Though the complex is nestled in a parklike setting and appears as it did in the early 1950s, tasteful inclusion of modern amenities that were made with an eye on preservation have contributed to making this a favored destination for enthusiasts. As with all of the successful historic businesses on Route 66, the people behind them are the key to their popularity.

Connie Echols's quick smile, attentive nature, and eye for detail ensure that a visit to Connie's Shoppe or an overnight stay at the historic Wagon Wheel Motel will be a most memorable experience. "I was tired of the flower business, and had a bit of the old-age crazies turning sixty, and I had a love for fixing up old things. The son of a former owner who was executor of the estate that included the property told me to make an offer for the motel, so I did and never thought the owners would take it, but they did," Echols said. "The biggest challenge was

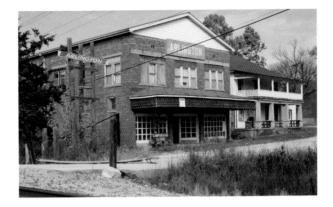

Predating the American Civil War, Arlington survived and prospered for almost a century before the bypass of Route 66 transformed it into a ghost town.

dealing with construction workers and convincing them that I sort of knew what I was doing."

Tying an overnight stay at the Wagon Wheel Motel with attendance of Cuba Fest, the third weekend in October, or a memorable dinner at Missouri Hick next door with its unique ambiance ensures that the novice Route 66 adventurer will understand just what makes the Route 66 experience addictive and infectious. It is also an example of why people from throughout the world make this quaint Ozark Mountains community a destination, and why they return repeatedly.

Quirky and offbeat attractions are integral to the Route 66 experience as they have been since the highway's inception. In Cuba, that attraction is rather obscure.

The Hayes Shoe Store serving the community since the early 1950s still offers the services of a cobbler. It is also home to a pair of oversized shoes, under glass, which once belonged to Robert Pershing Wadlow, the world's tallest man.

Born in 1918, Wadlow became a media sensation during the 1920s and 1930s as each year his height set new records. At age eight, he was taller than his father

was, and at the time of his high school graduation in 1936, he towered eight feet four inches (2.54 meters) tall. At the time of his death in 1940, he stood eight feet eleven inches (2.72 meters).

How did the "gentle giant's" shoes become a display in a shoe store in Cuba, Missouri? At age twenty, Wadlow contracted with the International Shoe Company of St. Louis to engage in a promotional tour for the company in exchange for financial compensation and custom-made shoes.

These custom shoes became displays at stores that sold products manufactured by the International Shoe Company; one of the stores was in Cuba. When Henry Hayes purchased the store, now Hayes Shoe Store, a shoe from Robert Waldow came with the acquisition. Later, International Shoe Company launched a promotion in which a Wadlow shoe that the company had filled with corn kernels was placed on display for customers to guess the number of kernels. After the promotion ended, stores were given an option to purchase the size 37AA shoe.

When current owner Jeff Bouse purchased the store, the shoes again were included in the sale price. When you stop by to see this interesting curiosity, buy a souvenir pin, and check out the selection of quality footwear. I did.

Route 66 westward from Cuba is a sensory delight, even though the sense of time travel is rudely broken with the need to cross over, or occasionally drive on, I-55 to the next exit.

In Fanning, smaller than the proverbial wide spot in the road, is the "World's Tallest Rocking Chair," which casts its shadow over the Fanning General Store. A few miles to the west is the charming 4M Vineyards & Farms Store, a roadside store that hearkens to a precorporate farm era where you can purchase fresh sorghum, pumpkin butter, wine, and all manner of jellies and jams.

In St. James, it isn't easy to overlook the world's first Vacuum Cleaner Museum & Factory Outlet Store, promoted with an advertisement that proclaims, "Get Sucked in to Learn about the History of Vacuum Cleaners."

Accessed via exit 176 on I-55 and a short but scenic drive along a truncated segment of Route 66 is the forgotten village of Arlington. Its colorful history dates

Today, the business district in Devil's Elbow, a quaint, quiet Ozarks Mountain community, consists of the post office housed in a small store.

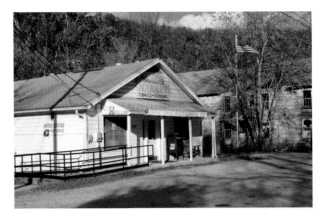

Near Jerome, a weathered store and long-abandoned cabins are vestiges from when Route 66 was still the Main Street of America.

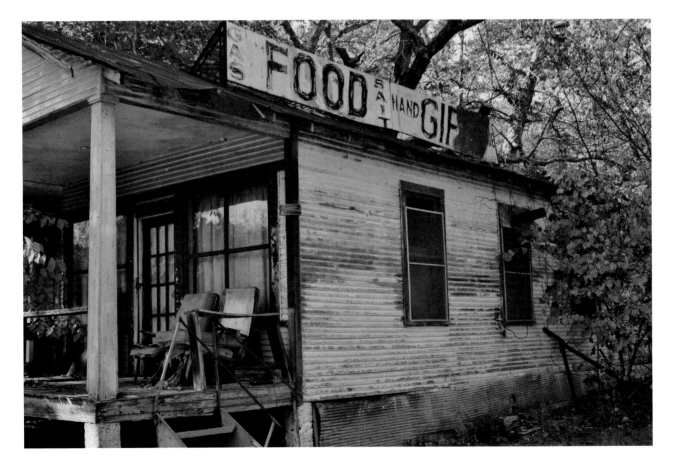

LEFT
Hooker Cut, an engineering marvel when built in the early 1940s, was the first four-lane segment of Route 66 in Missouri.

BELOW
The recently refurbished Devil's Elbow Bridge over the Big Piney River carried Route 66 traffic until 1943. It was built in 1923.

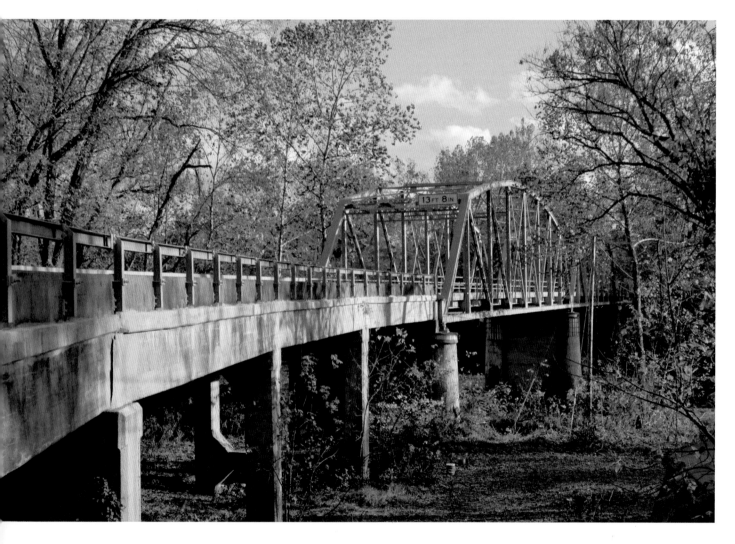

to the era of the American Civil War, but the picturesque setting is also associated with a pivotal moment in Route 66 history as it was here in January 1931 that a celebration commemorated completion of the paving of that highway in the state of Missouri. To celebrate, highway workers tossed coins into the wet cement.

Accessed via exit 172 is the west end of that now-truncated highway. Here the forest slowly reclaims the folk art masterpiece that is the Trails of Tears monument gardens as well as the last vestiges of the once-famous Stony Dell Resort.

Nestled between exits 169 and 159, embraced by stunning Ozark Mountain landscapes, is a microcosm of Route 66 highway engineering evolution, and some of the most memorable landmarks as well as tremendous photo opportunities.

Here, the empty four-lane segment of highway known as Hooker Cut has an almost apocalyptic feel as traffic is light to nonexistent and vines are reclaiming the rock walls. When built during World War II to alleviate the bottleneck that was the Devil's Elbow on the Big Piney River, the deepest highway cut in America received acclaim as an engineering marvel. As a historic footnote, this was the first segment of four-lane Route 66 in the state of Missouri, and the last segment bypassed with construction of I-55.

The section of Route 66 bypassed by Hooker Cut is today, as proclaimed by the state in 1941, one of the "Seven Beauty Spots of Missouri." Here, the narrow road twists and turns to the river, where a recently refurbished steel truss bridge built in 1923 provides wonderful photo opportunities, as does the sleepy village of Devil's Elbow.

A quirky landmark that is the cornerstone for a Route 66 landmark is the Devil's Elbow Inn & BBQ that opened as the Munger Moss, a sandwich shop in 1936. This is the classic dimly lit roadhouse complete with well-worn pool table and bar worn smooth by countless elbows. What sets this roadhouse apart from others scattered throughout America is its association with Route 66, and the ceiling decorations.

At some point in the distant past, for reasons unknown, women began providing their brassieres for the owner to hang from the ceiling. Today, women from throughout the world stop in to donate an undergarment, and the ceiling is festooned with curvaceous stalactites.

As idyllic and pristine as this section of Route 66 is, issues threaten the road's future as a time capsule to its centennial and beyond. Near Hazelgreen, a picturesque steel truss bridge built in 1923 carried Route 66 traffic across the Gasconade River until the winter of 2014, at which time the state deemed it structurally unsafe for vehicular traffic, largely the result of budget-induced postponement of maintenance.

Shortly after the bridge's closure, which resulted in the truncation of two scenic segments of Route 66, enthusiasts from throughout the world utilized social media to form a grassroots initiative to save the bridge from demolition. Attendees of a rally held at the bridge in early 2015 included members of the German Route 66 Association and enthusiasts from as far away as Arizona.

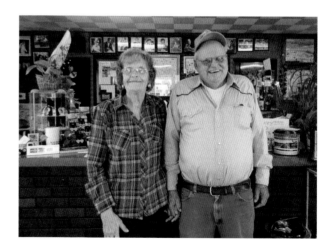

ABOVE

In 2016, a celebration commemorating Bob and Ramona Lehman's forty-five-year ownership of the Munger Moss Motel drew enthusiasts from throughout the world.

While the initiatives to save the historic Gasconade River Bridge exemplify the passionate spirit of the international Route 66 community, they also highlight the need for an organization similar to the US Highway 66 Association, created in 1927 to market and develop Route 66 as a linear entity. In 2013, with funding from American Express, the National Park Service Route 66 Corridor Preservation Program and World Monuments Fund collaborated to establish that organization with the Route 66: The Road Ahead Initiative. To date, development of the proposed organization has included the establishment of a steering committee; a meeting of that committee in Albuquerque, New Mexico, to draft a mission and goals statement, as well as basic structure outline; a series of town hall–type meetings held along the Route 66 corridor in the summer of 2015; and, in 2016, achieving the status of a 501(c)(3) nonprofit in the state of Illinois.

Lebanon is home to a venerable Route 66 landmark—the Munger Moss Motel and two charming people who personify the essence of what has made Route 66 the most famous highway in America, and who make this storied highway a destination for a legion of international travelers.

The sandwich shop that opened at the Devil's Elbow is the cornerstone for this icon. In about 1940, Nelle and Emmett Moss sold that restaurant to Jessie and Pete Hudson, who in turn sold the property and relocated to Lebanon after completion of the Hooker Cut and the bypass of the Devil's Elbow. In Lebanon, the Hudsons purchased the Chicken Shanty Café, a service station and restaurant complex on Route 66. In 1945, they renamed it Munger Moss Barbecue and the following year they added a motel that soon replaced the restaurant.

Record cold and snow dominated the winter of 1970 in Iowa. A particularly intense storm gave Bob Lehman, a former farmer and truck driver-turned-traveling salesman, the incentive to seek warmer climates. In April 1971, Lehman and his wife Ramona set out on a road trip to Missouri in search of opportunity.

In discussing the motel and their association with it and Route 66, Ramona said, "It was destiny. On our honeymoon in 1957 we journeyed to St. Louis and stayed in the King Brothers Motel on Highway 66. In the spring of 1971, we looked at motels in southern Iowa. Then in April we looked at motels on Route 66 in Springfield but didn't find what we were looking for. When we stopped for gas in Lebanon on the way home, a realtor at the station began talking with Bob, and then we stopped at the Munger Moss. Four days later we made an offer on that motel and owned it one month after that."

In discussing the era of Route 66 renaissance, Ramona said, "After the decommissioning of the highway, we had the occasional guest that was looking for the old road for sentimental reasons, and a few like Jeff Meyer and Jerry McClanahan that were exploring. I attended an event and felt like a kid at story time listening to Michael Wallis read from his book *Route 66: The Mother Road* in that deep voice of his and that sparked something.

"We are charter members of the Route 66 Association of Missouri. In recent years, there has been quite an increase in interest in the road, and many of the people we meet come back time after time. They seem like family."

Ramona's last statement speaks volumes about the unique nature of Route 66 today. Illustrating her point is a grassroots initiative to celebrate the Lehmans' forty-fifth year as proprietors of the Munger Moss Motel in April 2016. The celebration, linked to another rally to save the Gasconade River Bridge, attracted enthusiasts from throughout the United States as well as from Europe and Asia.

The Munger Moss Motel is one manifestation of Lebanon's pride in association with Route 66. In 2007, a stellar Route 66 museum opened in the Laclede County Library. A stunningly detailed diorama of Nelson's Dream Village, a long-vanished Route 66 motel, created by Willem Bor, a world-renowned model builder and avid Route 66 enthusiast from the Netherlands, is among the museum's prized exhibits.

As a historic footnote, Lebanon has association with a pivotal moment in Route 66 history. The first contract issued under the Interstate Highway Act on August 2, 1956, was for a 4.6-mile (7.4-kilometer) section to bypass

ABOVE

All along Route 66 in western Missouri, vintage service stations provide tangible links to the highway's infancy.

BELOW LEFT

The late Gary Turner of Gay Parita, in Paris Springs Junction, was often referenced as the goodwill ambassador of Route 66.

BELOW RIGHT

This vintage bridge immediately east of Spencer serves as a portal into another time.

ABOVE
Not easily overlooked is the sign at the entrance to Red Oak II.

BELOW
A variety of monuments commemorating the colorful history of Carthage enhances a walk through the courthouse square.

the community. Dedication ceremonies for completion of the project occurred on August 8, 1957.

From Lebanon to Springfield, Route 66 resumes the twisted course through the Ozarks and sleepy little towns and villages that make a drive seem almost timeless. The bucolic feel of the landscape changes rather dramatically a short distance from Springfield, another community associated with key moments in the road's history, as well as its future.

On April 30, 1926, Cyrus Avery of Tulsa, Oklahoma, deemed the Father of Route 66, met in the offices of John Woodruff in the Woodruff Building in Springfield to discuss possible compromises to resolve conflicts associated with the assignment of numbers to the newly created federal highway system. Avery had accepted an appointment to the US Department of Agriculture in 1925 to serve on a board tasked with developing and coordinating an interstate highway system that utilized a uniform system of markings as well as signs.

At the time of his meeting with Woodruff, the highway connecting Chicago with Los Angeles had a designation of US 60. Because of a compromise negotiated by Avery with the governor of Kentucky, this was changed to US 66, with official certification taking place in November 1926.

Springfield, as with numerous communities, has had a reawakening about the city's association with Route 66. If there were a cornerstone for this movement, it would be the Route 66 Rail Haven Motel, established in 1938.

The current owners have worked tirelessly to renovate and preserve the complex as it was, albeit with modern conveniences, circa 1960. As the property has a Best Western affiliation, this meant battling corporate policy in order to re-create historic neon signage for the property.

Indicative of the community's success in regards to harnessing the resurgent interest in Route 66 as a catalyst for development was the Birthplace of Route 66 Festival in August 2015. Only in its fifth year, the festival parade had more than four hundred entries, and an estimated twenty-three thousand people attended the event in downtown Springfield.

During the same period, three historic buildings reopened after extensive renovations. Among these was the Woodruff Building.

Target marketing of the wide array of historic sites in the immediate area, such as Wilson's Creek National Battlefield, to Route 66 enthusiasts will no doubt increase tourism. Numerous communities are linking area attractions to Route 66 promotion and seeing an uptick in tourism numbers.

Route 66 west from Springfield to the historic mining towns of Carthage, Webb City, and Joplin is another section of the old highway where the past, present, and future seem to flow together seamlessly. A landmark on this portion of Route 66 was the brainchild of the late Gary Turner, deemed affectionately by many as the ambassador of Route 66 and a 2016 inductee into the Route 66 Walk of Fame located in Kingman, Arizona.

Turner and his wife, Lena, turned their attentions toward the resurrection of Paris Springs Junction through the re-creation of Gay Parita, a roadside service complex established by Gay and Fred Mason in the early 1930s. Steve Turner, Gary's son, said, "I think with Dad being retired, this was an opportunity to bring something back to life. He had fond memories of buying an old car and fixing it up with his dad.

"So with the help of my uncle and my uncle's son, he built what is now known as Gay Parita." The result was a near perfect re-creation of a roadside service station circa 1930, complete with a grizzled but smiling attendant topped by a grease-stained oil company promotional hat. Completing the illusion was the refurbishment of the original stone garage and a scattering of various vintage vehicles in various states of disrepair.

However, what really made this little time capsule on an obscure segment of bypassed old highway in the foothills of the Ozark Mountains a destination was Turner himself. Rough around the edges, he was always quick with a joke or smile, provision of travel information, or a cold slice of fresh-cut watermelon on a warm summer's day. He was also supportive of new business endeavors all along the road and, during late night phone calls, he would offer advice as well as encouragement.

Shortly after Turner's death and the subsequent memorial that attracted people from throughout the United States and Europe, thieves ransacked the property, stealing numerous historic signs and artifacts. In spite of the setback and loss of Turner, Steve Turner reassured the world that Gay Parita would be welcoming visitors again soon. "A family member has stepped forward and is wanting to take the station and keep it going in the memory of Dad and the memory of Mom because they were Gay Parita, Happy Equal," he said.

In the summer of 2016, at the first European Route 66 Festival in Ofterdingen, Germany, the German Route 66 Association raised funds to assist the Turner family in the reopening of the property.

A few miles away, marooned on State Highway N, a nearly forgotten segment of Route 66 bypassed decades ago, is another time capsule. However, at this time the owners of Spencer, Missouri, have chosen to resurrect the remaining buildings accessed via a 1923 steel truss bridge on Turnback Creek, and let them stand as photo opportunities rather than open them as a business.

Near Carthage, Missouri, is an even more ambitious attempt to preserve and re-create the past, Lowell Davis's Red Oak II. "The 1930s seemed to be a much simpler time. Neighbors helping neighbors, everyone had a garden and canned their own food. They had a milk cow and even made their own clothes. By today's standards, they were poor, they just didn't know it!" Lowell Davis said on his website. That thought on the past coupled with fond memories of growing up in the small rural community of Red Oak are the cornerstone for his delightful creation.

After a successful career in the Dallas/Forth Worth area, Davis returned home to find that Red Oak was a ghost town. Like him, the people had left in search of the good life.

In 1987, Red Oak II was simply a cornfield on Davis's Fox Fire Farm outside of Carthage, but with the acquisition of one building at a time in Red Oak, and

their relocation twenty-three miles (37 kilometers) to the farm where they were refurbished, the re-created village began to take shape. Today Red Oak II, complete with folk art by Davis, dozens of renovated buildings including a Phillips 66 service station that once stood along Route 66, his great-grandfather's blacksmith shop, and a scattering of vintage vehicles and tractors, is a destination in itself.

Route 66 skirts scenic Kellogg Lake as it winds into Carthage. Nestled on the lakeshore are the Kel-Lake Motel and the Best Budget Inn, originally the Lake Shore Motel; both appear unchanged from early 1960s postcard views of the property.

Historic Carthage, with its stunning courthouse built in 1895 and charming square festooned with an array of monuments and memorials, is home to another manifestation of how the renewed interest in Route 66 is making it economically viable to renovate vintage properties. In this instance, it is the Boots Court, which dates to 1939.

As with most of the early motels on Route 66, the Boots Court evolved with the highway and the times. Designed and built by Arthur Boots, a farm machinery salesman by trade, the complex began with construction of a two-pump service station. The construction of four rooms behind the station that now doubled as a motel office, and an array of interesting experiments to save on construction costs, followed shortly afterward.

In these first rooms, the doors and most of the furniture were handmade, and incorporated into the construction of shower stalls were automobile windshields. A utility tunnel under the building and use of a large fan were to provide cooling.

The motel endeavor proved so successful that Boots removed the pumps and abandoned the idea of operating a service station. He also erected a red-and-white neon sign that read Boots Court, the sign that now renovated again serves as a beacon for travelers, and then added four additional rooms.

Shortly after the motel sold to new owners in 1946, the addition of another wing increased its profitability. Two years later, Reuben and Rachel Asplin acquired the motel. Even though Reuben died in 1974, Rachel managed the property until 1991. Incredibly, with new owners, it remained operational as a motel until 2001.

As with countless motels along Route 66, by the dawn of the new century, the value of the property eclipsed the value of an aging motel and such was the case when real estate speculator Vincent Scott acquired the Boots Court. Fortunately for the Route 66 community, plans to sell the property to a drug store chain looking for new locations never materialized.

After foreclosure and repossession, the current owners, sisters Debye Harvey and Priscilla Bledsaw, both avid Route 66 enthusiasts, acquired the property with a vision of restoring it as a retirement project that would allow them to interact with Route 66 travelers from throughout the world.

To date, the 1946 building again is ready to provide lodging for travelers. With painstaking attention to detail, and consultation with Bob Boots, Arthur's son, as well as former employees, the sisters are preserving as many original details as possible and re-creating others. An interesting touch has been to duplicate the 1940s experience by offering, as the sign says, a radio in every room. There are no televisions.

The Boots Court today is more than another example of how the Route 66 renaissance is transforming communities through historic preservation or how that movement is making it economically viable to revitalize mid- and early twentieth-century commercial structures. It also is another example of why Route 66 in the twenty-first century often is described as a "living, breathing time capsule."

Scattered about the historic courthouse square in Carthage are similar examples of how the international fascination with Route 66 is having an effect on communities large and small. One of these is the charming Mother Road Coffee, now a destination for Route 66 travelers and locals alike.

Under the guidance of Patrick Tuttle, director of the city's Convention and Visitor Bureau, in Joplin, the

ABOVE

The Boots Court is another example of how the Route 66 renaissance is fostering a preservationist movement for mid-century commercial buildings.

last community on Route 66 before it enters Kansas, the resurgent interest in Route 66 is being harnessed with rather dramatic results.

In 2013, the city hosted the Route 66 International Festival, then under the auspices of the Route 66 Alliance. The development of cooperative partnerships with the cities of Carthage, Webb City, and Galena, Kansas, greatly enhanced the event, which attracted thousands of Route 66 enthusiasts from throughout the United States and Europe. During the festival, a colorful multidimensional mural was unveiled, and shortly afterward Tuttle developed a program that allowed for the development of special events for tour groups.

Joplin is a community steeped in history, as well as a community that is embracing its Route 66 association, and Missouri is a microcosm of the challenges and the opportunities associated with this storied highway in the twenty-first century.

kansas

THIRTEEN
AMAZING MILES

Route 66 in Kansas is less than fourteen miles (23 kilometers) in length. In addition to having the least number of miles in any of the eight states that constitute the Route 66 corridor, Kansas is also the only state completely bypassed when the interstate highway replaced US 66 and it is also the only state where you can drive from border to border, on Route 66, without encountering an interstate highway.

Still, in this short distance is encapsulated more than 150 years of fascinating history, unexpected scenic wonder, and additional examples of the dynamic effect that the renewed international interest in Route 66 is having even in the most unlikely of communities.

Route 66 sweeps into Kansas past an old bar and a gritty area that provides little more than the faintest of hints that this was once a major industrial site. With the exception of ardent history buffs, few would know that this was the site of an intense and violent labor dispute, or that this dispute propelled Governor Alfred "Alf" Landon into the national spotlight, and to the Republican Party's nomination for president in 1936.

Between 1910 and 1940, the Eagle Picher Company, a lead-mining smelter that stood at this site, fought to quell unionization efforts with intensity. In May 1935, President of the United Mine Workers, John L. Lewis, called a strike and company management responded by hiring non-union workers from neighboring states and communities.

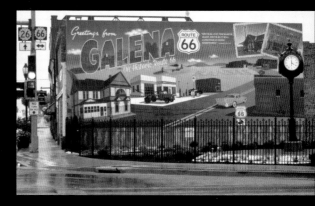

ABOVE
In Galena, the Route 66–fueled revitalization has manifested in pocket parks replacing empty lots or abandoned buildings.

OPPOSITE
The visitor center in Baxter Springs is another example of the repurposing that gives a new lease on life to

ABOVE

A refurbished Kan-O-Tex sign is another example of why Route 66 is referenced as a living time capsule.

OPPOSITE

The cornerstone for Galena's revitalization was a former Kan-O-Tex station and the passion of four women.

By midsummer, frustrated miners attempted to stop the flow of nonunion workers from Missouri by barricading US 66 near the state line. The sheriff rerouted traffic and contacted the governor for assistance. The governor responded by calling out the National Guard. In spite of the military presence and a checkpoint on Route 66, violence escalated; during a parade in April 1937, gunmen wounded nine people, an estimated four thousand men armed with pick handles attacked the union headquarters, and nine people were wounded by gunfire.

Today the site is quiet, almost bucolic in spite of the evidence of industrial degradation of the landscape. Then Route 66 crosses over the railroad tracks and into Galena, the oldest mining town in Kansas, on a recently refurbished concrete post viaduct, and in an instant, there is a palpable sense of vibrancy.

In what started as a Kan-O-Tex service station at 119 North Main Street and the former site of the Bank's Hotel (demolished in 1933), the three-way stop corner where Route 66 enters Galena is Cars on the Route, a landmark in the history of the Route 66 renaissance as well as a destination for countless Route 66 enthusiasts.

Acquired by four women, Betty Courtney, Melba Rigg, Rigg's sister Renee Charles, and Judy Courtney in 2007, the decrepit old service station mirrored the faded mining town of Galena. As renovations on the building progressed, and its transformation into a snack bar and souvenir shop developed, Melba would often stand on the corner handing out bottled water to travelers and invite them to stop. That simple beginning was the catalyst for the dramatic transformation of a community whose population had plummeted from 30,000 in 1905 to 2,995 in 2013.

Now, Cars on the Route is a destination in itself. The increasing number of travelers who stopped at the station inspired Mayor Dale Oglesby to facilitate innovative cooperative partnerships between business owners, property owners, and the city of Galena. The results are most impressive.

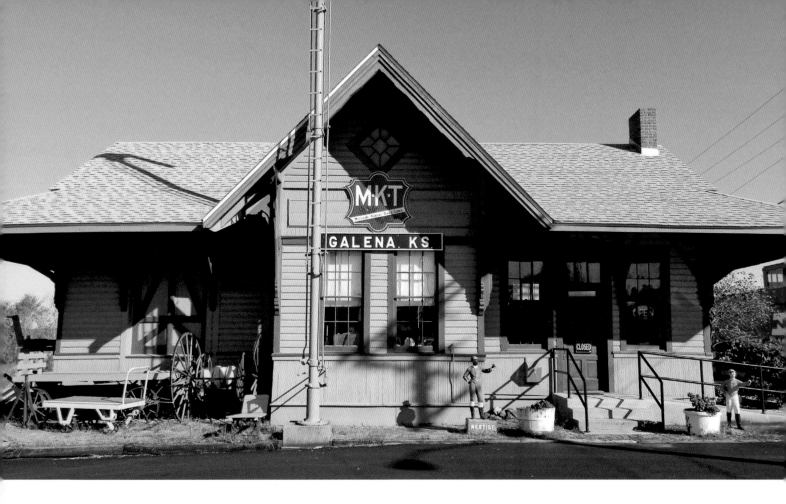

The Galena Museum chronicles the area's rich and colorful history, and provides visitors with a fascinating mineralogical display as well.

LEFT
Dries and Marion Bessels of the Dutch Route 66 Association included the joining of a community tree planting initiative on their annual Route 66 trip in 2015.

A long-abandoned late-nineteenth-century home across the street has been miraculously saved from imminent collapse and transformed into the "murder bordello," a bed and breakfast that capitalizes on the city's infamous Staffelback murders. Colorful murals and pocket parks have replaced debris-strewn vacant lots. Reproduction historic-styled street lamps add to the pleasant feel of the community. New businesses are opening, including several restaurants.

Ed Klein, developer of the popular Route 66 World website and Facebook page, recently purchased the former Front Street Garage complex that closed decades ago. His long-term plans for the property include a museum dedicated to the Ford Model A, a White Rose Gas Museum, and a small, replicated 1940s diner.

In a recent interview, Klein noted, "This is a long-term project. The next few years will have the façade and storefront brought back to the way it looked in 1947, and then the focus will be turned toward the inside."

When asked about the dramatic changes taking place in Galena and along the Route 66 corridor, Klein said, "We need to get new tourists on the route at an increased level each and every year. I believe we are doing this, but at a slower pace than we should. Also, I see more and more everyday folks taking a risk and purchasing Route 66 businesses, which are good for the route as well as the tourist."

Harnessing the resurgent interest in Route 66 as a catalyst for revitalization is transforming the former mining town. During the 2013 Route 66 International Festival, a special concert by the Road Crew held in Galena attracted several thousand people who filled the streets, shops, and restaurants. During the 2014 Route 66 International Festival in Kingman, Arizona, Dries Bessels, president of the Dutch Route 66 Association, presented Melba Rigg a model of Four Women on the Route created by internationally acclaimed Dutch model builder Willem Bor.

The development of a sense of community spirit in Galena is another byproduct of the Route 66–fueled transformation. In 2015, Bessels and clients of US Bikers, a Dutch-based tour company, working with Melba Rigg

ABOVE

After its destruction by tornado in 1923, the Eisler brothers built the current store that opened in 1925.

and other residents in Galena, planted trees as part of an innovative land reclamation project. Pieter Hoff, a Dutch horticulturist, designed a special grow box that allows for the growing of trees with limited amounts of water.

Renee Charles noted that, "earlier, several members of the Kansas Historic Route 66 Association attended classes held in Joplin to teach them about a product called the Groasis Waterboxx, an incubator for trees that allows them to grow, develop, and thrive in less-than-ideal environments. The first two trees planted in the United States using this technology were along the route during a ceremony. The Galena City Council purchased one hundred of the water boxes."

Galena is not the only community on the Route 66 corridor that is profiting from the renewed interest in this highway. On most any day during the peak tourism season on Route 66, April through October, the Eisler Brothers Store in Riverton that opened in 1925 to replace a store destroyed by a tornado serves a steady stream of customers. The only deviation from its original design

was the enclosure of the former shaded portico with gasoline pumps into an enclosed room for customers of the deli.

One of the most photographed sites on Route 66 in Kansas is the Brush Creek Bridge built in 1923. Listed on the National Register of Historic Places in 1983, it was built as a single-span Marsh Arch, named for architect James Barney Marsh, during construction of a modern highway to connect Galena and Baxter Springs. It is one of approximately seventy bridges of this type remaining nationally.

Marsh acquired a patent for his reinforced concrete arch bridge in 1911. During the teens, 1920s, and 1930s, resultant of their aesthetically pleasing design, hundreds of these bridges were built as part of highway improvement projects.

In 1992, demolition of two multi-span Marsh Arch bridges on Route 66 in Kansas sparked a grassroots initiative to save the Brush Creek Bridge. Its preservation stands as an early milestone in the era of renaissance. With publicity such as that garnered in 2000 when Brad Paisley performed "Route 66" on the bridge for a TLC channel program entitled *Route 66: Main Street America*, the bridge is also an internationally recognized symbol of the historically unique idiosyncratic nature of Route 66.

Baxter Springs has not been as quick to capitalize on the Route 66 renaissance as Galena, but that is changing. Of course, the decline of Baxter Springs was not as complete or as dramatic as that of Galena when mining ended and the bypass of Route 66 cut off that economic lifeline. Still, the population declined more than 10 percent in the first decade of the new century, and as of 2010, the population was 4,238.

Named for A. Baxter who established a tavern and inn near the namesake springs in 1850, the town had its most famous incident in 1863. Because of the importance of the springs, and a major road to Fort Scott, the US Army constructed Fort Baxter here. In October, a contingent of Confederate guerillas loosely known as Quantrill's Raiders attacked the fort. After being repulsed by a unit of the US Colored Troops, the guerillas surprised and massacred a contingent of Union troops in the process of relocating to Fort Scott.

A monument commemorating the Baxter Springs Massacre is a part of the self-guided driving tour that includes twelve markers showing the different actions that took place during the battle. Maps are available at the Baxter Springs Heritage Center and Museum, at Eighth Street and East Avenue.

The cornerstone for the town's efforts to capitalize on Route 66 is the Kansas Route 66 Visitor Center at the corner of Tenth and Main Streets. The former Phillips 66 service station listed on the National Register of Historic Places dates to the 1920s.

Colorful and unique characters are an important part of the Route 66 allure. At the visitor center in Baxter Springs, travelers often stop, hoping to meet Dean "Crazy Legs" Walker, former president of the Kansas Historic Route 66 Association.

In a 2006 interview with *The Joplin Globe*, critically acclaimed author Michael Wallis spoke of his first meeting with Dean Walker during his trip as guide for John Lasseter and the production team from Disney/Pixar that produced the animated film *Cars*: "Every time I turn over a rock, another genie emerges. And I turned over a rock one day and out came this frowning, blustering character named Dean Walker."

Walker, with his signature ability to turn his feet backward, made quite an impression on the production team as members transcribed this unusual trait into the backward-driving ability of the character Mater. Wallis said, "As luck would have it, we had just eaten a sandwich at the Eisler Brothers Old Riverton Store when we met Dean. He was proud as punch to show them his exorcist feet and regale them with stories of the Ghost Light, and so forth."

As a historical footnote, Baxter Springs has a direct association with baseball history. While playing for the Baxter Springs Whiz Kids, a minor league team, Mickey Mantle received his first check for playing baseball.

The short stretch through Kansas on Route 66 may be few in miles, but it is long in opportunity for memory-making adventure, people, and attractions.

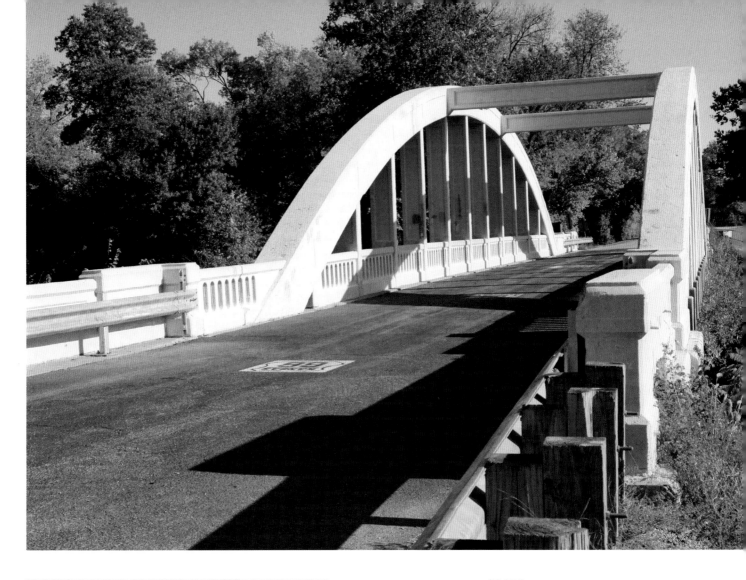

ABOVE
The stylish Brush Creek Bridge was one of the first victories won
by Route 66 preservationists working to preserve the
highway's historic character.

LEFT
In Baxter Springs, the bypass of Route 66 and the opening of a
Walmart fueled a decline in the historic business district,
but the corner drugstore survived.

WHERE THE WEST BEGINS

As in Kansas and western Missouri, vestiges that mining was once the economic mainstay of the area line the roadside in the first miles of Route 66 in Oklahoma, but a variety of other landmarks and links to a colorful history are here as well. In Commerce, 319 South Quincy Street, now a private residence, is the boyhood home of Mickey Mantle. Housed in a mid-1920s Marathon service station located at the corner of Main and Commerce Streets is a Dairy Queen. As Route 66 courses through Commerce, it passes by Mutt Mantle Field, a ballpark named for Mickey Mantle's father.

At the corner of Third and Main Street is a small park with a simple monument commemorating Constable Cal Campbell. East of the city, Campbell died in a gun battle with the ruthless duo Bonnie and Clyde, on April 1, 1934, Easter Sunday.

Miami is a vibrant community peppered with delightful architectural treasures, in part due to the embracing of a rich and colorful history, as well as a Route 66 association. At 103 North Main Street along the Route 66 corridor is the stunning Coleman Theater, a mission-styled masterpiece built in 1929. Listed on the National Register of Historic Places, the theater built by George L. Coleman Sr., a zinc-mining magnate, for a reported cost of $590,000 (approximately $8.2 million today), underwent a complete renovation in 1989 after the Coleman family donated it to the city.

Even though Waylan's Ku-Ku Burger was once part of a regional chain, it is a tangible link to an era before generic fast food emporiums dominated the urban landscape. From its quirky décor and colorful neon signage to its uniquely American menu that includes hamburgers and buffalo burgers, the restaurant fits perfectly in the Route 66 theme of the twenty-first century as it provides a link to decades of highway history

ABOVE
Dating to 1965, Waylan's Ku-Ku Burger restaurant is the sole survivor of once-prosperous regional chain.

OPPOSITE
Refurbishment of the towering Meadow Gold sign was accomplished through an unprecedented partnership between the National Park Service, state historic preservation office, Tulsa Foundation for Architecture, and the Oklahoma Route 66 Association. *Rhys Martin, Cloudless Lens Photography*

Accessed via South Main Street is an interesting evolutionary milestone in highway engineering. Billed as the Sidewalk Highway, this three-mile (five-kilometer) section of crumbling pavement that gently twists through farm fields to a point near Afton carried Route 66 traffic until 1937. Dating to construction of State Highway 7, a part of the Ozark Trail Highway network, in the period between 1919 and 1921, the roadway with concrete edging is a mere nine feet (2.74 meters) wide. In November 2011, near Afton, dedication of a monument commemorating the highway's historic significance occurred during a special ceremony.

Afton makes for a most interesting case study. The once-bustling community may not be a ghost town in the traditional sense of the phrase, but it is less than a shadow of what it was a century ago. Vestiges of more prosperous times abound; the long-abandoned Palmer Hotel, the former Pierce Wagon & Buggy Works building, an impressive brick bank building all hint that this was once a town with a very bright future. There is also ample evidence in the form of Afton Station that harnessing the resurgent interest in Route 66 could be the transformative catalyst for the community to stem or reverse the decades-long decline.

Laurel Kane, who passed away in January 2016, was the proprietor of Afton Station, a former D-X service station complex that now houses a small collection of Packard-built automobiles, a few vintage cars, a small gift shop, and an eclectic collection of Route 66 memorabilia. In a December 2015 discussion she said, "My wonderful staff of volunteers and I are always ready to visit with Route 66 enthusiasts and travelers. Each year about seven thousand visitors from every state and eighteen countries stop by the station."

In June 2003, Jim Conkle, on behalf of Hampton Inns, presented Laurel and David Kane with one of the company's Save-A-Landmark site markers. This was in recognition of the Kane's renovation of the property that included the replacement of pressed-tin ceilings, lighting, flooring, and windows, which restored the property to its mid-1930s appearance.

The popularity of Afton Station, now facing an uncertain future, in a town where the population is around eight hundred people and the business district consists of little more than a farm co-op store, a small restaurant, and a mini mart hints at the potential the renewed interest in Route 66 holds for small, rural communities. Still, surprisingly, not all communities grasp that potential, and Afton is one of these.

"I am sorry to say that I see very little fuel for revitalization in Afton," Laurel Kane said. "I don't know if this can be rectified or whether the town should just be allowed to die a slow, natural death. Not a day goes by that I don't ponder that question."

Ironically, in the pre-interstate highway era, Afton was a very popular destination and stop for Route 66 travelers as this was home to the world-famous Buffalo Ranch. Established in 1953 by Aleene and Russell Kay, the Buffalo Ranch initially consisted of seven head of

ABOVE
At most every turn in Afton, you'll find vestiges of more prosperous times.

OPPOSITE
Packard manufactured automobiles are the cornerstone for the founding of Afton Station.

APPROVED
Packard
SERVICE

buffalo purchased from a Texas breeder and the Buffalo Ranch Trading Post. By the end of the decade, the parking lot filled with cars bearing license plates from Maine, Oregon, Florida, and California, and more cars lining the highway shoulder for blocks in both directions was a common sight.

In an interview with Thomas Arthur Repp for his book *Route 66: The Empires of Amusement*, Aleene Kay said, "We had to work hard at it. We built as fast as we could afford to."

In addition to the original trading post, the Chuck Wagon Barbecue that specialized in buffalo burgers, the Dairy Ranch, and the Western Store that specialized in quality western wear were a part of the complex by 1960. American Indian dancers and an eclectic zoo that included deer, zebra, peacocks, and bison lured tourists from the road.

The high point of the ranch's publicity came in 1963 with the inauguration of President John F. Kennedy. A trained, performing bison from the ranch participated in the inaugural parade.

In Vinita, another landmark of note has survived into the modern era virtually unchanged. Located at 319 East Illinois Street, the course for Route 66 in that community, stands Clanton's Café, a rather nondescript building with the exception of its green-painted walls and towering red sign with EAT spelled out in white letters. Currently managed by Dennis and Melissa Clanton Patrick, this one family, the Clantons, have owned the restaurant since it opened in 1927.

Preserved along the course of Route 66, including on short segments of older alignments in Foyil, Chelsea, and Catoosa, from Vinita to Tulsa, are links to more than a century of highway engineering evolution and forgotten monuments to events that once were front-page headlines throughout the world. There are also a few unique attractions and additional examples of how fragile the historical integrity of Route 66 is.

At the east of Chelsea are two alignments of Route 66. The earliest alignment enters town on East First Street over the iron-truss Pryor Creek Bridge built in 1926 while the latter alignment that carries State Highway 66 crosses the creek on a 1932 pony bridge. Grassroots initiatives have saved the earlier bridge, but as Jerry McClanahan notes in his *EZ 66 Guide for Travelers*, "The 1932 pony bridge is doomed."

The historic bridges on Route 66, crucial for preservation of the highway's idiosyncratic nature, are among the road's most endangered structures. Conservative estimates are that more than 95 percent of the bridges on Route 66 are due or overdue for closure, replacement, or demolition.

Development of bicycle tourism along the Route 66 corridor is heavily dependent on these bridges, as is the preservation of the highway's historical integrity. In a few instances, such as with the Lake Overholser Bridge in

ABOVE

The 1926 bridge over Pryor Creek exemplifies the importance of preserving these historic structures to ensure that Route 66 remains as a complete time capsule.

OPPOSITE

The forlorn ruins of the Avon Court enhance the sense that Afton is less than a generation away from becoming a ghost town.

Oklahoma City and some of the Mississippi River crossings, it was determined that renovation of the bridges was less costly than replacement. Additionally, such as with the historic Chevelon Canyon Bridge in Arizona, there was benefit in preservation resultant of tourism interests.

Diminutive little Foyil is an intriguing time capsule in itself. It is also the gateway to one of the nation's premier folk art sites, Ed Galloway's Totem Pole Park.

The latter post-1963 alignment of Route 66, now State Highway 66, skirts the old town itself, or what remains of it. However, the original alignment signed as Andy Payne Boulevard with its Portland cement surface makes for an interesting detour.

Located at 12243 South Andy Payne Boulevard is a 1920s service station that closed in 1965. On December 8, 2015, current owner Kean Issacs, who has plans for the facility's restoration and transformation into a gift shop and information center, announced approval of the submission for a request that the building be listed on the National Register of Historic Places.

At the west end of the community, where the two alignments of Route 66 intersect, is a small park and a statue of the namesake for Andy Payne Boulevard. In the late 1920s, Andy Payne became an internationally acclaimed celebrity when he won a footrace from Los Angeles to New York City and in the process placed the newly christened US 66 in the spotlight.

C. C. Pyle, a sports promoter cut from the cloth of P. T. Barnum, devised an epic footrace that, in theory, would be a personally profitable venture that would also elevate his reputation. As the course for the footrace was from Los Angeles to Chicago on Route 66 before turning east toward the finish line in New York City, an early sponsor was the US Highway 66 Association.

The entry fee for participating runners was a then-astronomical $100, but the top ten finishers received cash prizes (the grand prize was $25,000). More than two hundred entrants, including professional marathon and long-distance runners, accepted the challenges. One of those was a nineteen-year-old Cherokee farm boy from Foyil, Andy Payne.

Officially billed as the First Annual International Trans-Continental Footrace, some journalists derisively dubbed it the Bunion Derby. It commenced on March 4, 1928, and culminated at Madison Square Gardens on May 26.

Payne was clearly an underdog. However, by the time the racers reached Texola at the Oklahoma state line, he had become the consistent front-runner and a media sensation. With a total time of 573 hours, 4 minutes, and 34 seconds, Payne bested the remaining fifty-five entrants to claim first place.

Payne used his winnings to pay off the family farm and purchase a farm of his own. Later in life, he served five terms as the clerk to the state supreme court.

Payne and Foyil itself would be little more than historic footnotes if it were not for their association with Route 66. In the spring of 2015, Atsuyuki Katsuyama, a Japanese ultra-marathon runner, set out to fulfill a quest that began in the 1980s when he learned about Payne.

"I have been running for thirty years," Katsuyama said. "I studied and trained to run one hundred–mile races. Then I started to think I wanted to run the longest distance in the world, California to New York."

With support from his wife, Neung, and another runner, Greg Wilson, who served as the support staff, and with partial financing from a friend in Germany, Katsuyama began what he called K's Run Across the USA 2015 at Santa Monica Pier on April 25. "Of course I enjoy the beauty of Route 66, especially when you see this huge country with such big horizon," Katsuyama said. His grand adventure culminated on July 12.

Claremore and humorist Will Rogers are forever linked; the Will Rogers Memorial and Museum is located at 1720 West Will Rogers Boulevard. Likewise, with Route 66, in 1952 the US Highway 66 Association led an

initiative to have that highway dedicated and signed as the Will Rogers Highway.

Claremore is also home to the J. M. Davis Arms & Historical Museum, 333 North Lynn Riggs Boulevard, which is Route 66. In 1946, promotion for the collection then housed in the lobby of the Mason Hotel proclaimed it the largest private accumulation of firearms in the world. Today, the collection consists of more than twenty thousand firearms that range from artillery pieces to centuries-old matchlock rifles. In addition, there is a collection of more than one thousand historic German beer steins, a collection of World War I recruitment posters, a macabre collection of nooses from various legal executions, and nineteenth-century music boxes.

Tulsa was home to Cyrus Avery, often referred to as the father of Route 66, and is the home of Michael Wallis, founder of the Route 66 Alliance and the author of *Route 66: The Mother Road*, the book credited as a cornerstone for the Route 66 renaissance. Still, until quite recently, Tulsa, as with most of the metropolitan communities along the Route 66 corridor, paid little heed to its association with that highway.

That, however, is changing and in a rather dramatic fashion. The Blue Dome District named for a uniquely designed state-of-the-art service station complex that opened in 1925, is at the center of the city's downtown district revival. Each year the Blue Dome Arts Festival and Mayfest fill a once-moribund district with vibrant festivities.

Nestled against the east end of the long-closed Cyrus Avery Bridge built in 1916 on the Arkansas River is Cyrus Avery Centennial Plaza, the first stage in a project being spearheaded by Michael Wallis that will include an expansive Route 66 museum as well as visitor center. A stunning bronze work entitled *East Meets West* dominates the plaza.

Rhys Martin of Cloudless Lens Photography represents more than the future of Tulsa; he also represents a new generation of Route 66 enthusiasts who have no direct connection to the road when it was still a certified US highway. "I grew up in Tulsa and its suburbs and didn't pay much attention to Route 66 until I was in my late twenties," Martin said. "I returned home after backpacking

ABOVE

The cornerstone for revitalization of the business district along the pre-1932 alignment of Route 66 in Tulsa is the uniquely styled Blue Dome Station that opened in 1925.

OPPOSITE

The Golden Driller is a 76-foot-tall commemoration of the city's rich heritage as a metropolis built on the oil industry.
Rhys Martin, Cloudless Lens Photography

through Southeast Asia and Europe for ten months and sought out the historical significance of my hometown, digging into Tulsa's rich oil capital history, represented by the Golden Driller statue at the Tulsa State Fairgrounds and the heritage of the Mother Road.

"I started with the giant Meadow Gold sign at Eleventh and Peoria and worked my way out, eventually traveling the entire route from Chicago to Los Angeles. The recent influx of small business development on Route 66 excites me greatly, as does the proposed Route 66 Experience Center right across the street from the Cyrus Avery Memorial Bridge, for which funding is currently underway."

When discussing the reborn interest in Route 66 in Tulsa, Martin noted, "If Springfield, Missouri, is where Route 66 was born, Tulsa is the place where the road was conceived. Still, like much of Route 66, much of the corridor in the city limits fell into neglect."

He continued, "However, a decade of revitalization of Tulsa's historic Oil Capital downtown district has spread to both alignments of the route. The Blue Dome district houses several farm-to-table restaurants. The current alignment, known as Eleventh Street, is home to a number of antique shops, boutiques, and restaurants with more

Dating to 1923, the recently renovated Bristow Motor Company, listed on the National Register of Historic Places, blends the past and present, with a touch of the future, without sacrificing the historic attributes of the complex. As an example, the vintage appearance of the Bolin Ford sign hides the fact that it is a wind generator.

On South Roland Street, Route 66 is the relatively nondescript Anchor Inn. Hamburgers and traditional American diner food dominates the menu as it has since 1950.

In contrast is nearby Depew, the first town on Route 66 to suffer economic hardship because of highway realignment and a bypass that occurred in 1928. The now-quiet business district of red brick buildings includes an empty but superb example of a 1920s-era service station and garage, and an array of buildings of similar vintage.

The revitalization of Stroud is due in large part to the diligence and perseverance of Dawn Welch, inspiration for the character Sally Carrera in Pixar's animated classic *Cars* and the proprietor at the historic Rock Café, and her husband, Fred. Dating to August 1939, the café is an institution in the community with multigenerational employees; mothers who first worked at the café while in high school now work with their daughters.

Construction commenced in 1936, but as the owner, Roy Rives, often worked alone pouring the foundation one wheelbarrow full of cement at a time or utilized help from local high school boys, it took three full years to complete the building. The Rock Café remained in operation for decades, but by the early 1990s, it needed extensive renovation. After acquisition by Dawn and Fred, utilizing original plans, the renovations commenced.

With receipt of a cost share grant from the National Park Service Route 66 Corridor Preservation Program that allowed for completion of the renovations, the Rock Café garnered inclusion on the National Register of Historic Places in 2001, and it appeared in the filming of an episode of *Diners, Drive-Ins, and Dives*. In 2008, a major fire gutted the venerable old restaurant. With

opening every month. Of particular note is Ike's Chili, open since 1908 and Tulsa's oldest operating restaurant."

All of this renovation is having a two-fold effect on Tulsa. The city and its residents are awakening to the potential associated with harnessing the resurgent interest in Route 66 as a catalyst for revitalization of economically depressed neighborhoods. Route 66 enthusiasts are awakening to the unique attributes of the highway's corridor in a major metropolitan area.

From Tulsa to Oklahoma City remnants from the faded history of Route 66 and territorial Oklahoma stand in stark contrast to shining examples of preservation or the adaptation of old buildings for new purposes, due in large part to the renewed interest in Route 66. Bristow is a stellar example.

ABOVE
Unique urban architecture such as the triangular "milk bottle building" on the 1926 to 1930 alignment of Route 66 make a drive through Oklahoma City interesting.

ABOVE LEFT
Between 1926 and 1954, Route 66 carried traffic around the state capital building in Oklahoma City.

LEFT
World-renowned author of the *EZ 66 Guide for Travelers* and artist Jerry McClanahan, and "Rootie" at the Miles of Possibilities Conference in Edwardsville, Illinois, in fall 2015.

an outpouring of support from Stroud and the Route 66 community, and financing from the National Trust Southwest Office and the National Park Service, the restaurant reopened in 2009.

Stroud has another relatively obscure landmark that makes it a destination for "roadies," the affectionate term applied to passionate Route 66 enthusiasts. A series of dirt roads that twist and turn westward before connecting with State Highway 66 served as the original alignment of Route 66 until 1930. It also carried Ozark Trail Highway traffic during the teens. Towering over the encroaching brush at an intersection is a graffiti-adorned obelisk, a very rare marker from that early highway system that was also another project associated with Cyrus Avery.

Davenport, Chandler, and the almost-ghost town of Warwick, like Bristow, are a blending of the old, the new, and the destinations for a new generation of Route 66 enthusiasts such as the gallery of Jerry McClanahan, author of the *EZ 66 Guide for Travelers*. However, it is in tiny Arcadia that the blending of past, present, and future is most evident.

Crowning a small knoll is the Round Barn, built in 1898 and resurrected from near complete collapse by local volunteers. Today it houses a small Route 66 museum, as well as a visitor center and hall for special events. Directly across the highway is Pop's, an intriguing blending of 1950s malt shop, modern mini mart, and souvenir stand with more than five hundred different brands of soda pop and a futuristic service station. The towering LED-lit pop bottle can be seen at night for miles.

In August 2015, work commenced on the century-old Brooks Building in the shadow of the Round Barn. The new tenant is Joel Rayburn of GlassBoy Studios and Tourist Trap Tees. Rayburn collaborated with Route 66 authors and historians Jim Ross and Shelle Graham, Arcadia residents, to create and develop Tourist Trap Tees and his historic neon sign re-creations are garnering critical acclaim after the installation of a sign at the iconic Blue Swallow Motel in Tucumcari, New Mexico.

In Oklahoma City, the Route 66 reawakening has not been as dramatic or as concerted as in Tulsa.

However, preservationists spurred by enthusiasts have scored several major victories, including renovation of the Tower Theater with its uniquely styled marquee.

As with most metropolitan areas, realignment of Route 66 in Oklahoma City to meet the evolving traffic needs and the growth of the city resulted in the utilization of numerous streets. Tracing some of these becomes impossible, as the streets are now truncated or obliterated because of interstate highway construction. However, as is often the case with Route 66 exploration, seeking out these vestiges can result in some surprising discoveries.

As an example, this is the only state capital in the United States to have operating oil wells on the grounds. On Classen Street, a pre-1930 alignment of Route 66, traffic flows around a diminutive triangular building adorned with an oversized milk bottle similar to the way a stream flows around a rock. Tragically, on most of the alignments, vestiges with a direct association to Route 66 have vanished because of modernization and urban renewal.

However, an outstanding example of how to couple preservation and urban planning seamlessly is located on the west side of the city on the shores of Lake Overholser. Here the 1958 incarnation of four-lane Route 66 now carries the brunt of traffic along the Thirty-Ninth Expressway, while the beautiful 1924 steel truss bridge provides access to the parks on both sides of the lake. Route 66 Park on the west side features an interpretive walk with information about the eight states that constitute the Route 66 corridor and a statue of Andy Payne.

Though the landscapes on the east and west side of Oklahoma City appear similar, there is a distinct sense of being out west when you leave the city. Enhancing the feeling are colorful murals in Yukon that commemorate the historic Chisholm Trail or vintage markers for Fort Reno, a military complex established during the Indian wars of the mid-nineteenth century that contribute to this perception. As an interesting historical footnote, Fort Reno served as a German POW camp during World War II.

From El Reno to Hydro, purists revere this section of Route 66, as the roadway has survived intact from the 1930s. Curbed concrete roadway, sweeping curves, a lack

Register of Historic Places in 2004, the park retains numerous architectural elements, including the brick pillar supports and neon-lit Art Deco–style sign that frames the entrance. These are from its construction between 1934 and 1937.

The National Route 66 Museum, Farm & Ranch Museum, Blacksmith Museum, and Old Town Museum, part of a sprawling complex in a parklike setting in Elk City, offer an expansive interactive opportunity. From the giant kachinas relocated from the old Queenan's Trading Post at the entrance to the pink 1950s Cadillac convertible ingeniously linked to modern technologies, which allow you to "drive" a section of Route 66 through Oklahoma, the complex is quite unique.

The collections and displays are almost overwhelming in their scope. Cowboy and rodeo memorabilia donated by the world-famous Beutler Brothers Rodeo Stock Producers dominates most of the second floor in a beautiful Victorian-styled home. At the Blacksmith Museum, visitors watch as blacksmiths transform iron and steel into tools and horseshoes. In addition, a Native American Gallery displays the traditional and historic artistry from numerous tribes.

The museum complex is an example of how the intertwining of a community's historic association with Route 66 and its own unique history can result in the creation of a destination that appeals to Route 66 enthusiasts, as well as people unfamiliar with the highway's renaissance. Attractions such as these serve a very important role in maintaining and expanding the resurgent interest in Route 66 since it introduces a wider audience to the allure of the highway.

The last communities in western Oklahoma on the Route 66 corridor make for interesting case studies. Erick and Texola are both communities with colorful histories. The distance separating the two towns would easily allow a developmental and promotional partnership to form similar to the one between Joplin and Galena. In addition, both communities contain the type of quirky attractions that appeal to the modern Route 66 enthusiast.

of shoulders, and the crown jewel—the almost one-mile-long Canadian River Bridge that consists of thirty-eight "pony" trusses built in 1933—a near-perfect time capsule.

Weatherford is a progressive, prosperous agricultural community with a vibrancy rooted firmly in its colorful history, which includes Route 66. On the east side of town, Lucille's Road House mimics the construction of a rare service station complex, Lucille's, in Hydro. The Stafford Air & Space Museum honors the town's most famous former resident, astronaut Thomas P. Stafford.

The Heartland of America Museum that opened in 2007 chronicles the area's history, as well almost 150 years of American societal evolution. The expansive grounds feature additional exhibits, including a small diner that Elvis Presley favored during his trips across Oklahoma.

Stellar museums associated directly with Route 66 have transformed Clinton and Elk City into destinations. With narration and developmental consultation by author Michael Wallis, the Oklahoma Route 66 Museum in Clinton presents the entire evolution of Route 66 from the Ozark Trails Highway era through the highway's decommissioning with an interactive self-guided narrated tour. In addition, there is a large gift shop and bookstore, and photo exhibit.

The McLain Rogers Park in Clinton is another interesting attraction of note. Listed on the National

ABOVE
The picturesque Lake Overholser Bridge enhances a visit to Route 66 Park, with its eight-state interpretive walk and a statue of Andy Payne.

RIGHT
As evidenced by the Thomas P. Stafford aeronautical museum in Weatherford, Route 66 connects the past with the future.

BOTTOM RIGHT
The Farm & Ranch Museum that includes a blacksmithing exhibition on the grounds of the National Route 66 Museum provides visitors with a multifaceted experience.

OPPOSITE
Colorful murals that commemorate a community's unique history, such as this mural in Yukon, add a sense of vibrancy to historic business districts.

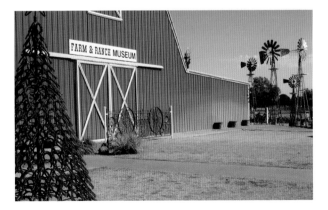

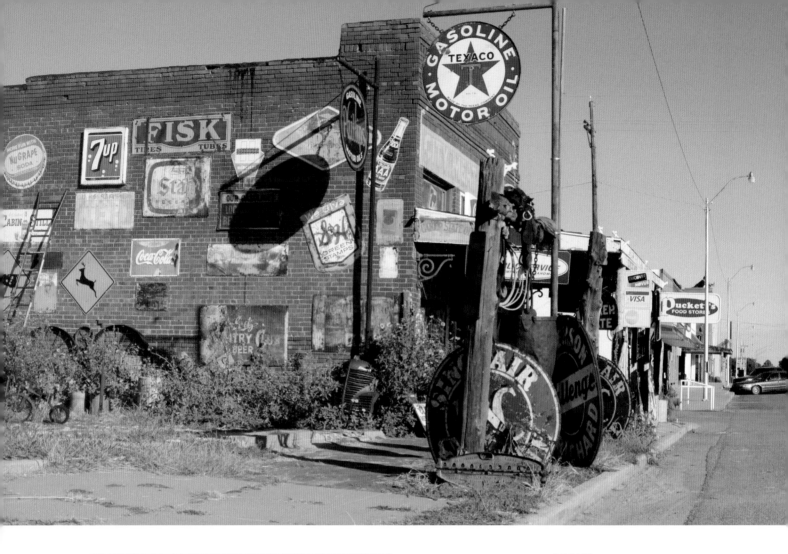

The Sandhill Curiosity Shop in Erick is indicative of the quirky
attractions that make a Route 66 experience unique.

LEFT
In Texola, the revived interest in Route 66 that is transforming
communities has come too late.

Yet, the communities languish. Erick maintains the faintest of pulses. Texola can easily be classified a ghost town.

In Erick, there is a feeble attempt to market the town's association with Roger Miller and Sheb Wooley that includes banners and street signs that indicate that these celebrities are the namesakes for the two main drags. While these names may be quite familiar to an older generation, they have almost no name recognition for enthusiasts too young to have a relationship with Route 66 when it was still a certified US highway. Annually the number of visitors to the Roger Miller Museum declines. That is indicative of the challenges associated with keeping Route 66 relevant to its centennial and beyond.

The Sand Hills Curiosity Shop housed in a century-old meat market adorned with a staggering array of vintage signage is a primary attraction. With a blending of redneck-tinged Vaudevillian bawdy humor and song, Harley and Annabelle, the Mediocre Melody Makers, became international sensations. However, the recent death of Annabelle may jeopardize Erick's future as a destination.

Route 66 was and is still a highway of opportunity, of dreamers, of risk takers, and of shirttail entrepreneurs. In Texola with its shell of a 1930s-era school and a business district that consists of a block or two of tumble-down empty storefronts and service stations, Masel Zimmerman and Tumbleweeds Grill and Country Store in Waterhole No. 2 is a manifestation of the future on Route 66, as well as its past.

Starting with the shell of a Depression-era café, Zimmerman painstakingly created a destination for Route 66 enthusiasts with colorful murals, excellent pie and coffee, and a few T-shirts. However, even when fueled by the resurgent interest in Route 66, opening a successful business in a ghost town, where the few remaining residents are content with the way things are, is a daunting task.

Route 66 in Oklahoma crosses into the Texas Panhandle in a rather anticlimactic fashion with only a tilted Will Rogers's marker, broken concrete, and asphalt roadway stretching toward the distant horizon, and the modern era made manifest by traffic on the interstate highway that zips past to close out the last miles.

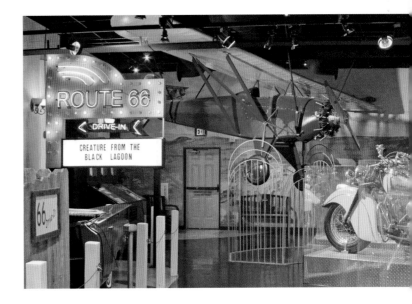

ABOVE
The expansive and interactive exhibits at the National Route 66 Museum provide visitors with a complete sensory experience that encapsulates a full Route 66 experience.

BELOW
Masel Zimmer, the hardworking visionary beyond the Tumbleweeds Grill.

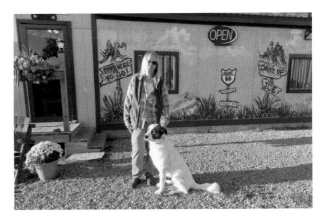

ACROSS THE PLAINS

Rolling into Shamrock, the first town in Texas after leaving Oklahoma on Route 66, there is ample evidence that the bypass that rerouted traffic along the interstate highway to the north of town had an adverse effect on a business district that had thrived for decades. First impressions change rather abruptly as you near the junction with US Highway 83 overshadowed by the tower of the historic Tower Conoco and U-Drop Inn.

Built in 1936 by J. M. Tindall and R. C. Lewis, this complex has done more than merely survive into the modern era. It has become an internationally recognized landmark of the Route 66 renaissance and a link to the highway's past, as well as its future.

The uniquely styled structure appears prominently in the animated movie *Cars*, and at Cars Land in Disneyland. Under the guidance of Larry Clonts, director of the Shamrock Economic Development Corporation, with the addition a Tesla charging station in 2015, it became symbolic of Route 66 as the crossroads of the past and future.

That is only one manifestation of Clonts's vision. He said, "In April 2014, we officially converted the U-Drop Inn to make it the Shamrock Visitor Center. We offer our visitors free coffee or tea and Wi-Fi. We also expanded the gift shop, and added Cars Corner, where the kids can watch *Cars*."

He added, "In August 2014, Dora Meroney and I represented the Old Route 66 Association of Texas at the Route 66 International Festival in Kingman, Arizona, and I made a presentation on our progress to date as an association and shared thoughts on how we can improve experiences along the entire route. At the festival, I learned of an initiative to make Route 66 an electric highway and connected with folks from Tesla also attending the event."

ABOVE

With the addition of Tesla charging station, the classic U-Drop Inn became another crossroads of the past and future on Route 66.

OPPOSITE

Sunrise at the U-Drop Inn blurs the line between past and present.

"Our Tesla station opened in February 2015," he continued. "During our annual St. Patrick's parade and festival, we had five Tesla automobiles participate and display at the car show here at the U-Drop Inn. Also in February, I obtained written permission from the Texas Department of Transportation to paint Route 66 stencils on the stretch of old highway through Shamrock from city limits to city limits. This is important to all of our travelers and especially to the international travelers who make up approximately 50 percent of our visitors each year."

Clonts was also instrumental in the passage of state House Bill 978 that proclaimed the 178-mile (286-kilometer) path of Route 66 in the Panhandle a Texas Historic Corridor. This project can serve as a template for the Route 66: The Road Ahead Initiative steering committee to move forward with plans to have the entire highway declared a national historic trail.

In 2014, signatures in the guest book tripled. The following year indicated another rather dramatic increase in visitors.

The U-Drop Inn is one manifestation of how Shamrock is utilizing the resurgent interest in Route 66 as a catalyst for development and revitalization. A Holiday Inn Express recently opened on US Highway 83 behind the U-Drop Inn. Across the street, the 1960s-era Western Motel, renovated by the Patel family, is a favored stop for groups and travelers on Route 66 as it provides a front row seat for the lighting of the neon at the U-Drop Inn. During the peak Route 66 tourism season, the clientele at Big Vern's Steakhouse one block east of the motel are just as likely to be from the Netherlands, Australia, or Germany as they are to be from area ranches, or even Texas.

McLean, the next town of any consequence to the west and the last Route 66 town in Texas bypassed by the interstate highway, has all of the attributes needed for it to become another Shamrock, or Cuba, or Pontiac. Even though it has Delbert Trew, a soft-spoken, hard-working, passionate Texan who has spent most of his life in McLean, that hasn't been enough to spark a revival.

McLean has a colorful history that includes a direct link to the sinking of the *Titanic*, a story told at the surprisingly interesting Devils Rope and Old Route 66 Museum that preserves the entire history of barbed wire in a former brassiere factory that once garnered McLean the unofficial title, "Uplift City." There is a former World War II POW camp just outside of town. There is even the pleasant Cactus Inn Motel, a classic mom-and-pop survivor from the days when Route 66 was literally the main street.

Aside from the museum, among the long-closed theater, forlorn and empty business district, and overgrown vacant lots are vestiges, however, that the town still has a vital pulse. There are colorful, vibrant murals, and the Red River Steakhouse, a very popular restaurant for locals and travelers alike that catered the dinner for the 2011 Route 66 International Festival in Amarillo.

In the Panhandle, Route 66 is most always visible from Interstate 40, and most of the towns listed at the exit signs would need a few more people to qualify as

wide spots in the road. Many are even void of the ruins that make for good photo opportunities.

Still, there is something unique, something special, about Route 66 in Texas. In part, this is due to the distant horizon that never changes with the passing of the miles and the blurring of the line between past and present that results from Route 66 and I-40 running parallel across the prairie. The true ghost towns, the empty places such as Jericho with its weathered and forlorn auto court, also enhance a feeling that you are finally "out west."

Surprisingly, a few of the old towns, though diminished greatly from the glory days when Route 66 funneled thousands of cars every day through town, still have a business district. Groom, known for its leaning

ABOVE

At Big Vern's, a traditional steakhouse, real cowboys share a place at the bar with enthusiasts from the Netherlands, Germany, Australia, the Czech Republic, and dozens of other countries.

OPPOSITE

With each passing year, McLean, the last Route 66 community bypassed in Texas, slides closer to becoming a ghost town.

ABOVE
Community spirit in McLean is manifested in well-maintained, colorful murals that adorn many walls.

LEFT
In Groom, a now-empty Route 66 still serves as the main street.

OPPOSITE
Bob "Croc" Lile is yet another example of the colorful, unique, and fascinating people on Route 66 who become attractions themselves.

water tower, built at an angle on purpose to promote a long-vanished truck stop, and the Cross of Our Lord Jesus Christ, the largest cross in the western hemisphere standing at 190 feet (58 meters), is one of those dusty towns.

A well-kept residential district, towering grain silos, a market, a hardware store, a service station, and The Grill invite the casual traveler to stop, to sample a bit of small-town America circa 1960, or even 1950. There is even a well-kept motel, the Chalet Inn, which provides basic lodging for a surprisingly reasonable price.

Amarillo is the big city in the Panhandle. It is a bustling, modern community with a very old heart. It is also unique among Route 66 communities in that it has two very famous attractions and neither one of them are actually on that highway: Cadillac Ranch and the Big Texan Steak Ranch.

Even more surprising, these attractions dominate the must-see list so much that the later alignment of Route 66, West Amarillo Boulevard, and the historic Sixth Avenue, the original alignment, which courses through some of the city's oldest business districts, are often bypassed.

Nestled along the original alignment of Route 66, in the historic San Jacinto neighborhood, are an array of interesting shops, galleries, and restaurants housed in architecturally unique buildings. One of these is the Golden Light Café, serving locals and travelers alike since 1946. Also, found here are colorful characters of the type that make Route 66 adventures memorable, but few anywhere are as colorful and enjoyable as Bob "Croc" Lile, the artist and proprietor of Lile Art Gallery at 2719 Southwest Sixth Avenue.

Another notable personality on this segment of urban Route 66 is Dora Meroney, owner of Texas Ivy as well as the treasurer for the Historic Sixth on Route 66 Association, president of the Panhandle Tourism Marketing Council, and president of the Old Route 66 Association of Texas. Her eclectic shop is an orderly version of grandmother's attic.

"Our real involvement with Route 66 did not begin until 1997," Meroney said. "However, my father had a used

car lot in Amarillo since the 1960s and on Route 66 since the 1980s. While he never owned the property where his car lot was, he did buy the property adjacent to it and that is where Texas Ivy is located today."

Amarillo, as with so many communities, has been relatively slow to capitalize on Route 66 popularity, especially as a catalyst for the revitalization of its historic districts. That, however, is changing.

"In the city of Amarillo, since our new Convention & Visitors Council director started about three years ago, I can honestly say that the travel and tourism section has done much more promotion for Route 66 than had been done prior to his taking over. He can see the potential gold mine that Route 66 is and knows that if promoted correctly, it not only helps all of the business on the Route but the city as well," Meroney said. "As far as Texas goes, thanks to all new leadership in our 'border towns' of Adrian/Vega and Shamrock, they are embracing Route 66 and its travelers and have seen more visitors in the last two years than the decade before. Still, on a statewide level I am not sure that the State of Texas knows or understands Route 66 potential

or what it loses everyday by not promoting the Mother Road. The one positive thing from the state is our historical designation that Larry Clonts secured for us in 2015."

The communities of Vega and Adrian that Dora referenced are gems on the prairie. Both are little more than diminutive villages, yet each has capitalized on their unique attributes as well as their association with Route 66. In Vega, the primary attraction is the restored 1920s Magnolia gas station, and in Adrian, the Midpoint Café and park and Sunflower Station.

As the name implies, the Midpoint Café is located at the geographical midpoint of Route 66. Of course, that is dependent on which alignment you reference, but that technicality is overlooked by enthusiasts who stop at the park for an obligatory photograph as a souvenir.

The Midpoint Café is a thriving little throwback restaurant as the interior presents the illusion that it is still 1956, the year that the restaurant opened as Jesse's Café. Fresh-baked pies and coffee and traditional American diner food dominate the menu, and farmers as well as tourists from dozens of countries and most states fill the stools and booths.

Long closed but with signs that renovation has commenced is Tommy's Café, better known by its unofficial title, Bent Door Café, located just east of the Midpoint Café. This quirky little restaurant is a link to an era when an ambitious entrepreneur with a bit of vision could profit tidily from a location on Route 66, especially if there was a way to differentiate it from hundreds of other diners and cafés scattered along the highway.

Built by Bob Harris on the site of Kozy Cottage Camp that burned in December 1947, the restaurant has some rather unique attributes as a result of Harris's limited budget at the time of construction. The most noticeable of these are the cantilevered doors and windows salvaged from an Army Air Corps control tower purchased at a military surplus auction.

The last community on Route 66 in Texas straddles the border with New Mexico. It is a most unlikely destination for legions of travelers from throughout the world. However, as an internationally recognized symbol of the communities devastated by the bypass of Route 66, and an opportunity to experience a true ghost town, it is ideally suited.

Glenrio dates to the establishment of a siding and depot for the Chicago, Rock Island & Gulf Railway at the site in 1906 and the surveying that led to the division of the land as farms that had commenced the previous year. It was a rather prosperous little agricultural community when establishment of the Ozark Trails Highway allowed for diversification of its economy in the teens.

By 1926, the year Route 66 replaced the Ozark Trails Highway, the business district included the Glenrio Hotel, a land office, cafés, gas stations, garages, a hardware store, and a dry goods and grocery store. There was even a weekly newspaper, the *Glenrio Tribune*, published between 1910 and 1934.

The droughts of the late 1920s and early 1930s, the postwar recession of the early 1920s that led to a collapse of agricultural prices, and then the Great Depression forced the community to rely almost entirely upon commerce provided by the flow of travelers on Route 66. Then in 1955, rail service was suspended, and in 1975, with the completion of Interstate 40, Exit 0 provided access to a town that people bypassed as they rushed on toward the metropolis of Amarillo or the town of Tucumcari.

In less than two years, the town that had survived droughts, economic depressions, the societal upheaval induced by two world wars, and the near complete abandonment of its original agricultural economic base became a literal ghost town. By the dawn of the twenty-first century, the population was five.

In 2007, the seventeen remaining buildings that constituted the business district and the four-lane roadbed that was Route 66 received recognition for their historic significance with inclusion in the National Register of Historic Places. The designation, however, has not translated into revival or even preservation.

Still, the town is a destination for enthusiasts who stop for photos, to experience the deafening silence of a

ABOVE

Larry Clonts and his assistant Diane shepherd the revitalization of Shamrock by capitalizing on Route 66.

ABOVE

In the western Panhandle, deer are a common sight along Route 66.

once-bustling town, an authentic ghost town. It is rather fitting that one of the most photographed locations is the remains of the Texas Longhorn Motel and Café, established by Homer and Margaret Ehresman in 1950. The promotional claim to fame for this complex was a towering sign that read, "Last Stop in Texas" on one side and "First Stop in Texas" on the reverse side.

Route 66 across the Texas Panhandle begins and ends with ghost towns. In between is ample opportunity to experience Route 66 as it was, and as it will be in its centennial.

THE LAND OF ENCHANTMENT

Heading west on Route 66, travelers enter New Mexico through the ghost town of Glenrio, and then along pre-1956 Route 66, now a dusty county road, past the ruins of Endee and into San Jon. On the other hand, they enter on Interstate 40 with a stop at Russell's Travel Center located on the latter alignment of the historic highway. In either case, there is an almost-immediate sense that a drive through this state, the Land of Enchantment, on Route 66 will be quite special.

Shortly before crossing the state line, the landscapes change in a rather dramatic fashion. Almost in the blink of an eye, the highway drops from the plain, down an escarpment of broken cap rock, and into distinctly western landscapes of rolling hills and horizons dotted by distant mountains and mesas.

These landscapes embrace the first community of any size in New Mexico. Tucumcari, its rather dramatic decline after the bypass of Route 66, and its ongoing renaissance make this historic high desert town a unique place where the entire history of Route 66 is preserved. It is also another example of the transformative effect that the resurgent interest in Route 66 is having in communities large and small, and the challenges associated with creating a unified sense of community and community purpose that is crucial to maximizing the potential of the highway's renaissance.

Due to its proximity to Tucumcari Lake, one of the few dependable sources of water year-round in this part of New Mexico, and the unique landmark of Tucumcari Mountain, numerous historic trails crossed the plains at this location. The community itself dates to 1901 and the establishment of a siding for the Chicago, Rock Island & Pacific Railroad.

ABOVE

To journey along Route 66 in New Mexico is to understand why this state proclaims itself the Land of Enchantment.

OPPOSITE

Vintage and unique signs are an attraction for some Route 66 enthusiasts affectionately referred to as "sign geeks."

The Ozark Trails Highway, and later, establishment of the junction of US Highway 54 and US Highway 66, fueled a steady growth in service industry businesses: garages, services stations, campgrounds, motels, cafés and restaurants, and towing companies.

By the mid-1950s, red billboards that proclaimed "Tucumcari Tonight—2,000 motel rooms" were a common sight along the Route 66 corridor for hundreds of miles east and west of the city. In 1959, according to a New Mexico Department of Transportation study, an average of eight thousand vehicles per day flowed through town.

The bypass of Tucumcari, and Route 66, with I-40 decimated the town's economy. The population plummeted, businesses closed, and the quaint little town seemed destined to fade into oblivion. Then the reawakening began.

Façades received a new coat of paint, and murals added color and vibrancy even to vacant buildings. The razing of other abandoned buildings gave the Route 66 corridor a cleaner look. Renovation of the Motel Safari that opened in 1960 commenced in 2008 after its acquisition by Richard and Gail Talley. Long-dormant businesses reopened.

Arguably, the crown jewel of Tucumcari, and perhaps, the entire Route 66 renaissance movement, is the Blue Swallow Motel. Its neon signage and trim has made it one of the most photographed sites on the highway. The family management and operational team is a throwback to the infancy of Route 66, as well as a glimpse of what the future holds for the Route 66 community.

Built in 1939, and listed on the National Register of Historic Places in 1993, the Blue Swallow Motel is a rare example of the prewar auto court as it retains the original structure of rooms connected by open front garages. Most motels enclosed these garages to create additional rooms in the 1950s.

Kevin Mueller said, "We came to Route 66 partly out of necessity, and partly by choice. After Nancy and I became unemployed in February 2011, we went through a process of soul searching before deciding that we definitely wanted to take the opportunity to have our own business. Whether by sheer dumb luck or divine intervention, we decided to look at what opportunities Route 66 had to offer."

In further explaining their acquisition of the property, Mueller noted, "We had visited Tucumcari in 2007 and felt drawn to this southwestern part of the route, and discovered the Blue Swallow for sale. Spending our first night under the neon, chatting with fellow guests on a warm March evening, watching the proprietor showing rooms and filling up the place, we were overcome by the magic and fell in love with the place.

"We invested everything we had in purchasing the business, literally making the Blue Swallow our retirement. As much as we loved the property, we did not come as benevolent curators; the motel would have to pay her own way and provide a living for our family."

Before Kevin and Nancy Mueller acquired the motel, it was famous, and even popular. However, it lacked an atmosphere of infectious, passionate vibrancy, the infusion of the owners' spirit of excitement and enthusiasm, and that is what makes the difference between a popular Route 66 business and a Route 66 destination, a must-see stop on every traveler's list.

Utilizing social media, the new owners made it easy for guests and fans to connect, to become a part of the Blue Swallow experience. Today, that includes live-feed cameras linked to the website.

ABOVE
Tucumcari has come to symbolize the devastation wrought by the bypass of Route 66 and the challenges associated with revitalization based on the highway's growing popularity.

RIGHT
A vintage Model A Ford truck is one of the vehicles used by Kevin Mueller to ensure guests at the Blue Swallow Motel have a unique experience.

OPPOSITE
The Blue Swallow Motel is perhaps one of the most famous and most photographed places on Route 66.

ABOVE
All along Route 66, the lines between past, present, and even future are often blurred.

LEFT
David Brenner, and his wife, Amanda, owners of the Roadrunner Lodge, epitomize the passion, the dedication, and the vision of a new generation of Route 66 business owners.

With attention to detail, they focused on ensuring that a stay at the Blue Swallow Motel is an experience. In essence, the motel is a resort where guests enjoy period-correct rooms upgraded tastefully with modern amenities and partake of communal picnics with other guests, shuttle service in vehicles that range from a 1929 Ford truck to a vintage Pontiac convertible, and an array of special events in the courtyard.

As with businesses on Route 66 decades ago, the Blue Swallow Motel is family operated and managed. Recently, the Muellers' son, Cameron, and his wife, Jessica, joined the business. As the majority of business owners and Route 66 travelers are middle aged or senior citizens, this could encourage a younger generation to seek opportunity in Route 66–associated business endeavors.

When discussing their involvement at the Blue Swallow Motel, Jessica Mueller said, "We moved to the motel in July 2014 from Lexington, Kentucky. Cameron was ready to move on from his job, and I wasn't too attached to mine. I don't even remember who it was that brought up the possibility of us moving out here and helping Kevin and Nancy, but one day we pretty much decided to do something crazy and unlike anything anyone our own age was doing."

Jessica continued, "I will be interested in seeing how Route 66 grows within the next few years. We have found that there aren't many people, if any, affiliated with Route 66 our age or even that close to it. I know we all want to see positive growth along the road."

Mentors are crucial in any field if a new generation is to keep traditions and enterprises alive. For Jessica Mueller, that mentor was the late Gary Turner of Gay Parita in Paris Springs Junction, Missouri. "It was either our second or third visit with Gary when a small group of travelers in Corvettes stopped at his station. He told me to walk up to them, introduce myself, and talk with them," she said.

Turner served as a mentor for the entire Mueller family. In addition to visits, he often called to offer encouragement and advice. The Muellers were not the only recipients of his support. A number of fledging business owners credit him as a contributor to their

success, which is one of the reasons he and his wife were inducted into the Route 66 Walk of Fame during ceremonies in 2016 in Kingman, Arizona.

The success of the Blue Swallow Motel, the Motel Safari, and other properties and the Muellers' eager willingness to encourage others to take on similar endeavors, is contributing to the transformation of Tucumcari and, as a result, the revitalization of the entire Route 66 community.

Among the most recent success stories in Tucumcari is the ongoing renovation of the Royal Inn by David and Amanda Brenner. The Royal Inn, now the Roadrunner Lodge, began as the La Plaza Court built in 1947 and Leatherwood Manor built in 1964. An extensive remodel in the early 1980s joined them as one property.

Amanda Brenner said, "I don't know when I first developed an interest in motels, but I have a book on motel architecture, *Motels*, dated 1957. My mother worked for the Los Angeles County Library System and rescued it from a discard pile at least thirty years ago."

Brenner further explained: "David and I kept talking about buying a lodging property where we could live onsite and actually interact with the travelers, and viewed quite a few properties in different areas of the country, but the one qualifier we completely agreed upon was Route 66. I combed the internet often for commercial property listings for motels that looked like they might work. We viewed several Tucumcari properties, a few in Williams, Arizona, and even the now-gone Overland Motel in Needles, California.

"I found a 1940s motel in Holbrook, Arizona, that hadn't been updated for at least twenty-five years and it had quite a unique sign that I loved. We negotiated for months with the owners, and finally, at an impasse, I started a new search," Brenner said.

Continuing, she added, "During that new internet search, what was then the Royal Inn showed up as a property for sale. Being fans of Tucumcari, we had seen this property many times. We had peered in the windows and walked through the parking lot. It always looked almost, but not quite, open. We had seen it listed online for

over a million dollars, which was ridiculous, but now it was listed for much less by an out-of-state seller. We weren't in love with it, but we made an appointment to view it."

With patience and steadfast tenacity, the Brenners are now restoring the expansive complex one wing at a time. They are already receiving accolades and favorable reviews, and a long list of loyal repeat customers.

The long-term plans for the complex continue to evolve. Amanda Brenner noted, "We would like to return the property to as close to original as we can, possibly operating the two buildings under two different names."

The Brenners, Muellers, Talleys, and the Engmans, Gar and Heidi from Iowa who recently purchased Teepee Curios, are breathing new life into Tucumcari. Still, the town has yet to experience the dramatic transformation and revitalization of towns such as Pontiac, Galena, or Cuba. The unified sense of community and community purpose, a crucial element needed for a city to harness the resurgent interest in Route 66 as a catalyst for economic development, still seems to be missing.

West of Tucumcari, Route 66 courses through ghost towns and quintessential western landscapes, and past a string of photogenic ruins that were once prosperous roadside business, and in places where there is no option but to drive on I-40. It is a somber drive that lends itself to reflection on the past, present, and future of Route 66.

Those reflections expand to a question of why after arriving in Santa Rosa. This community has all of the attributes needed for it to become a destination in the era of resurgent interest. There is an eclectic and interesting automobile museum as well as a historic Route 66 restaurant that serves quality food at reasonable rates, the one-of-a-kind Blue Hole Park, and an array of historic buildings spanning the period from the late nineteenth century through the 1960s.

Yet the town remains much as it was after completion of the I-40 bypass, a faded relic. There is even evidence that rather than experiencing a revival, Santa Rosa continues its downward slide.

Originally, west of Santa Rosa, Route 66 turned north in a broad loop through Santa Fe before dropping

into Albuquerque. In the late 1930s, a massive realignment, the most dramatic in the highway's history, that commenced with a political squabble in the 1920s and creation of a state highway, placed it on a more direct westward course that is for the most part the route of I-40 today. In fact, the interstate highway has largely obliterated Route 66 from Santa Rosa to Moriarty.

The older alignment, however, remains largely intact. As Route 66 followed the ruts of the Santa Fe Trail, and El Camino Real, on this loop, there is a tangible sense of diverse cultural history not found anywhere else on the highway. Even the ghost towns and dusty villages feel different.

Dilla is rooted in the Anton Chico Land Grant of 1822. In the plaza at Tecolote, in 1846, General Stephen Kearny announced that the citizens were now part of the United States territory. The little chapel in San Jose has cast a shadow over the Santa Fe Trail, National Old Trails Highway, and Route 66.

In the late sixteenth century, the chronicler for the Coronado expedition noted that the sprawling Pecos Pueblo, now the centerpiece of Pecos National Historic Park, was the largest inhabited community discovered north of Mexico City. The nondescript adobe ruins at Pigeon Ranch belie the fact that this is the site of a hostelry on the Santa Fe Trail that dates to the 1850s, and that the only remaining building served as a field hospital during the Battle of Glorieta Pass in the American Civil War.

Santa Fe itself dates to 1608, the year construction of a new capital commenced upon the ruins of an older American Indian settlement. Vestiges from the city's association with Route 66 are scarce, largely resultant of the fact that realignment in 1937 ended that relationship. The historic and beautiful El Rey Inn is a rare exception.

From Santa Fe, Route 66 initially descended La Bajada Hill on what was once the El Camino Real in a series of sharp switchbacks. Indicative of the rich history along this section of the Route 66 corridor, evidence documents that the Santa Domingo Pueblo near "the hill" predates the era of Spanish exploration in the closing years of the sixteenth century.

Albuquerque, one of the oldest cities on Route 66 with origins dating to 1706 even though Spanish cartographers in 1540 noted a village at the site, is one of the few metropolitan areas to utilize the resurgent interest in Route 66 as a catalyst for redevelopment. However, most of that focus has been on the Central Avenue corridor, the post-1937 alignment of Route 66. Surprisingly, enthusiasts often overlook the older alignment that enters the city from the north on Fourth Street.

LEFT

In 2012, Albuquerque introduced a sweeping series of initiatives as a Route 66 corridor development plan that included the creation and installation of distinctive signage.

BELOW

Linked to enhancements along the entire Route 66 corridor is the expansive revitalization of the historic business district in Albuquerque.

OPPOSITE

The El Rey Inn is a treasured gem along the pre-1937 alignment of Route 66 in Santa Fe.

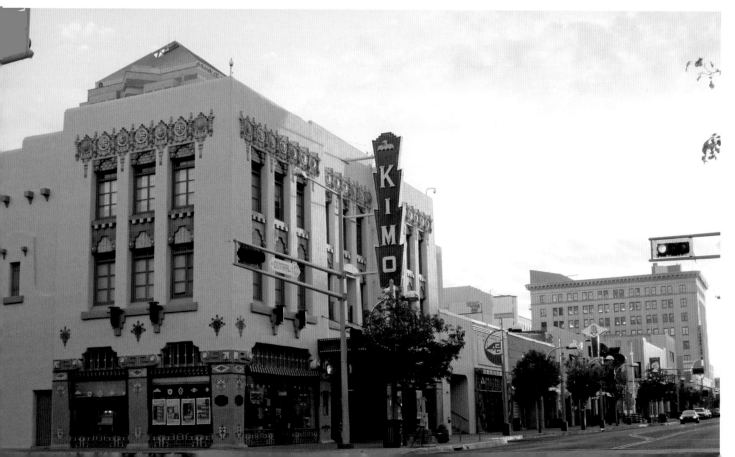

The preservationist movement that has swept along the Central Avenue corridor in recent years has, to a degree, stemmed the tide of urban redevelopment that resulted in the demolition of numerous historic properties, especially the motels that once dominated the east side of the city. Many, however, remain listed as endangered in spite of inclusion on the National Register of Historic Places. In 2015, a controversial plan to transform Central Avenue with establishment of an urban transportation corridor further threatened some surviving businesses.

The repurposing of historic buildings and complexes and the restoration of others in Albuquerque could serve as a template for other metropolitan areas as they turn toward Route 66 as a catalyst for revitalization. Examples include an architecturally unique 1930s Ford dealership with Art Deco façade that now houses Kelly's Brew Pub, the 1952 Hiland Theater and shopping center, a strip mall built in 1947, and the Nob Hill cultural district.

The core of the city's historic business district is also experiencing revival. The Hotel Andaluz, the first Hilton hotel, is an internationally acclaimed boutique hotel. The KiMo Theater built in 1927 serves as a cultural events center. Maisel's Indian Jewelry, 1939, remains an authentic Indian goods store.

Route 66, Central Avenue, skirts the Old Town District, with more than 150 museums, restaurants, and shops; some are housed in buildings more than 150 years old. Preserved here are the very origins of the city.

Surprisingly, most of the surviving motels directly associated with the historic Route 66 period serve as low-rent apartments, are now office complexes, or face an uncertain future with plans for revitalization or demolition. There are, however, a few exceptions. The Monterey Non Smokers Motel is one of the most outstanding examples.

This motel initially opened in 1946 as the Davis Court. With the motel now renamed and modernized, the AAA Accommodations Directory for 1954 lists the Monterey Court as, "a 15 unit court with tiled combination shower baths, individually controlled vented heat, playground, and radios."

Today, the motel provides the traveler with an authentic 1960s experience. Exceptionally clean and well maintained, the motel also appeals to the non–Route 66 enthusiast because of its budget price and proximity to major attractions such as the Old Town District.

Historic preservation along the Central Avenue corridor west of the Rio Grande River, as it begins the climb up Nine Mile Hill, has lagged behind the eastern and central sections. As a result, urban modernization has erased many historic buildings with a Route 66 association, and those that remain, with few exceptions, are in jeopardy.

Immediately to the west of the city, near the summit of Nine Mile Hill, just above the historic Rio Puerco Bridge, the Enchanted Trails Trading Post and RV Park offers another glimpse at how the history of Route 66 can be preserved in a manner that makes a business a destination.

Established in about 1947—give or take a year—as the Hill Top Trading Post, the main building originally stood in what is now the median for I-40. In late 1949, with announcement that Route 66 would become a four-lane highway west of Albuquerque, the owner dismantled the building and rebuilt it on the north side of the highway to capture traffic that was climbing out of the city on the long grade from the Rio Grande River Valley.

As with successful businesses on Route 66, then as now, it evolved with the changing needs of the public. In 1969, after acquisition by Al and Dorothy Felson, the addition of a campground transformed the business.

In 1988, Vickie Ashcraft bought the property. She noted, "When I started work here, there was no mention of Route 66 at all! A few years later Michael Taylor with [the] National Park Service stopped in and urged me to search out Johnnie Meier. A few more years passed and I was privileged to take a road trip to St. Louis with Jim Conkle and Bob 'Croc' Lile."

"That trip changed my life and made me a forever believer in the Mother Road," Ashcraft added, "and the power it has to bring people together. Now a day doesn't pass without some mention of 66, whether it be in the news, a tour, an article, or [from] a lone tourist. An awful lot of work on the part of a lot of talented, creative people has once again made Route 66 a household name. It is hard to imagine what the future will bring as more people get involved and the momentum grows. As far as my place is concerned, I can't tell you how exciting it is to see tour groups actually stop here! They don't stop in droves like Seligman, but wow, the number of visitors increase every year."

Aside from the trading post and modern RV park, and Vickie's infectious smile, the lure for Route 66 enthusiasts is an opportunity to experience lodging of a historic nature. Fittingly, Ashcraft has collected and renovated a collection of vintage travel trailers now rented as motel rooms.

These range in size and shape from a diminutive 1963 Winnebago that sleeps one to a mammoth 1959 Spartan that features a double bed, a sleeper sofa for additional guests, a full bath, and a complete kitchen. Other trailers that serve as motel rooms include a 1969 Airstream, a 1974 Silver Streak, and a 1956 Yellowstone.

The original alignment of Route 66 followed the Rio Grande south from Albuquerque before turning west at Los Lunas, a town that dates to the 1850s with initial settlement taking place with ranching. This allowed for the bypass of Nine Mile Hill but added miles to a drive to

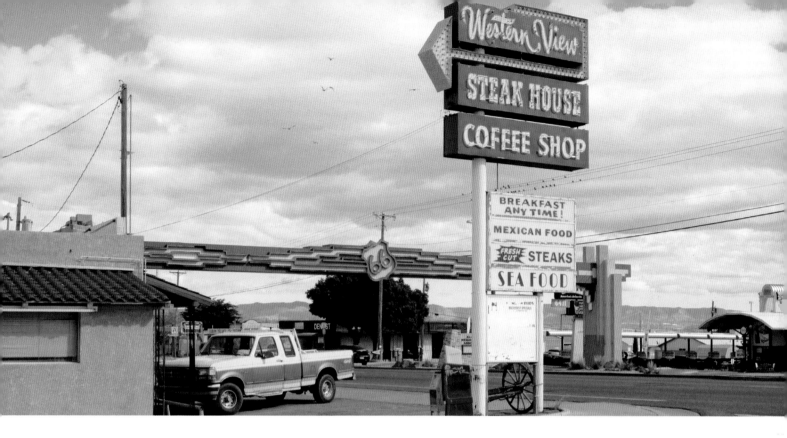

ABOVE
The preservationist movement that has transformed many sections of the Route 66 corridor in Albuquerque has yet to fully develop along the west end of Central Avenue.

LEFT
Passionate dedication, a winning smile, and innovations such as transforming vintage travel trailers into motel rooms have transformed the Enchanted Trails Trading Post into a destination.

OPPOSITE TOP
In Grants, the old theater is a surviving business along the Route 66 corridor.

OPPOSITE BOTTOM
The Monterey Motel, dating to 1946, is a rare survivor as many of the dozens of motels that lined Central Avenue during the era of Route 66 have been repurposed or demolished.

ABOVE
In the months of winter, snow often adds a whimsical touch to the
colorful landscapes where Route 66 crosses
the Continental Divide.

LEFT
Decorative touches on the streets of Gallup serve as
links to Native American culture.

OPPOSITE
The lobby of the El Rancho Hotel in Gallup appears unchanged
from the 1940s, when it was a haven for the rich
and famous from Hollywood.

California on Route 66, and it was prone to washouts due to floods of the Rio Grande and Rio Puerco.

As Route 66 courses west from Mesita to Gallup, the landscapes become more dynamic, and the term "Land of Enchantment" becomes more than a promotional descriptor. The scenic beauty and history are made manifest in places such as the Laguna Pueblo where construction commenced in 1698 become a rich tapestry tied together by historic Route 66.

The communities, and most historic businesses along this section of Route 66, even Grants, are heavily dependent on traffic flowing along I-40 for survival. As a result, the most prosperous areas are nestled around the highway exits, and empty storefronts are the dominant features along the business loops that once were Route 66.

It is doubtful whether the renewed interest in Route 66 can restore any semblance of vitality to communities such as Cubero, site of the only cemetery for Confederate veterans on Route 66, or San Fidel. However, Grants retains many of the attributes that other communities have successfully utilized as a catalyst for revitalization. As the international interests in Route 66 escalates, and as a new breed of entrepreneur seeks opportunity in long-neglected cafés, theaters, and motels, it will be interesting to see if the town continues its downward spiral or if it will become another Tucumcari.

Gallup remains a vibrant community. However, the fact that the historic district remains integral to the community with few empty storefronts, and that the community has yet to make a dedicated and concerted effort to capitalize on Route 66, it is unique.

For Route 66 enthusiasts, the centerpiece of Gallup is the El Rancho Hotel built in 1937 and billed as the "World's Largest Ranch House." Surprisingly, even with the addition of modern amenities the complex appears unchanged making this a unique opportunity to experience a five-star resort, circa 1940.

The stunning landscapes in the Gallup area and the fact that the primary builder in the area was R. E. Griffith, brother of movie mogul D. W. Griffith, helped Gallup develop a reputation as a suburb of Hollywood, and more than eighteen major pictures were filmed here between 1940 and 1964. The hotel also served as a recreational resort for celebrities.

Often referred to as a collection of time capsules, the historic district of Gallup is an architectural treasure trove. Businesses here reflect the city's long association with the Navajo, Zuni, and Hopi people. The historic El Morrow Theater contains an array of American Indian themes in the decorative façade. The founding family operates the Richardson Trading Company, an authentic Indian trading post that predates Route 66 by a decade.

A large number of period motels remain with original signage. Even though most now serve as long-term rentals, it is conceivable that as the Route 66 renaissance gains momentum, Gallup could experience a revival as a Route 66 community. However, as with numerous communities on Route 66, the galvanizing leader who can fuel a grassroots movement is still a missing component.

Though the last miles of Route 66 in New Mexico are through stunning landscapes, the drive is rather anticlimactic. In part, this is due to the fact that most of the drive through the state is an endless series of stunning photo opportunities, historic sites, opportunities to meet with people embracing the resurgent interest in Route 66 with passion, and communities experiencing a renaissance of their own, but here only photo stops remain.

THE LAND OF OPPORTUNITY

Route 66 in Arizona starts with great promise; colorful rock walls that stretch skyward serve as backdrops for a variety of trading posts that appear as though lifted from Kodachrome postcards from the 1950s. Hugging the state line are the remains of a movie set from 1950 turned trading post and a trading post linked to a murder at Two Guns in 1926.

Tragically, however, between the state line and Holbrook, Route 66 is little more than short stretches of gravel road, bits of broken asphalt, and the occasional picturesque bridge over a canyon or dry riverbed severed from the road it once connected. Still, amazingly, a few of these remnants have become destinations, icons that serve as the anchor for events that attract international participation in remote rural communities.

Chief among these is the ruins of the Painted Desert Trading Post marooned on a long-abandoned segment of Route 66 east of the Painted Desert Visitor Center in Petrified Forest National Park, the only national park bisected by Route 66. Built in the early 1940s on a knoll above the Dead River, the trading post was in such a remote location that it lacked phone or electrical service up until its closure in late 1956 or early 1957.

LEFT
The Route 66 corridor in Holbrook is lined with colorful storefronts, vintage motels, long-shuttered businesses, and whimsical creations.

OPPOSITE
Route 66 enters Arizona beneath towering cliffs that shadow traditional roadside Indian trading posts.

The scenic location that serves as a backdrop for the ruins of the trading post, the old highway stretching across the picturesque and colorful desert plain, and the haunting image of the historic Dead River Bridge below have come to symbolize the adventure of the Route 66 experience in the modern era. Dries Bessels, a founding member of the Dutch Route 66 Association, said, "On a trip to the Four Corners area I saw Russell Olsen's book, *Route 66: Lost and Found*, with a picture of the Painted Desert Trading Post on the cover. At that time, we had heard about Route 66 but in a way that everybody in the world has. You know the song and think you know that the road is still out there, but you're not very sure where exactly."

Bessels continued, "When I saw the picture of the Painted Desert Trading Post on the cover, I simply knew that I had to go there and see the building in real life. Then, around 2007, a young friend of ours went from healthy with a small child to dead from aggressive liver cancer in less than three months. We went to the funeral, and the next morning I decided I was not going to wait anymore. No more, bucket list. That same day we, Marion and I, decided we would go and ride all of Route 66 on a motorcycle and we did so in 2009.

"That year I went to the trading post on a motorcycle. I have been doing that every year since then on the annual Route 66 trip."

Holbrook, the community closest to the national park, has yet to harness the resurgent interest in Route 66 as a catalyst for revitalization. That, however, began to change when in 2014 a group of volunteers working with the City of Holbrook, and the National Park Service, took a major step toward making the community a destination for enthusiasts, on at least one weekend each year.

The city's Route 66 festival, aside from the traditional activities of music, car show, and presentations, included exclusive guided tours along Route 66 in the Painted Desert, a section of roadway closed to public access for decades, to the Painted Desert Trading Post with stops at other abandoned roadside businesses. In 2015, the second year of the festival, attendees traveled from as far away as Texas, Oklahoma, and Illinois to partake of the unique tour.

ABOVE
The old jail in the historic Navajo County Courthouse was used from the closing years of the nineteenth century through the first seven decades of the twentieth century.

OPPOSITE
The Globetrotter Lodge in Holbrook is a manifestation of how international interest in Route 66
is transforming communities.

Two historic Route 66 sites of particular note are in Holbrook; both are indicative of how the highway continues to evolve. Wigwam Village, currently operating as the Wigwam Motel and still operated by the original family, opened in 1950. The owners have deftly balanced the preservation of the complex in as original a state as possible while providing the modern amenities expected by today's travelers. Indicative of their success is the fact that reservations must be made weeks in advance during the peak season.

Almost directly across the street is the Globetrotter Lodge. In 1956, this property operated as the Whiting Motor Hotel and in the 1960s as the Sun 'N' Sand Motel. The doors closed in 2001 and vandalism transformed the property into an eyesore.

Mona and Peter Hoeller of Austria bought the derelict motel in 2009. Mona said, "Peter and I wanted

a change. So, we sold our house and business at home,
and traveled the world to have a look at where we might
want to live. We fell in love with the Southwest and
found this hotel in Holbrook that was in our budget.
We applied for an investor visa and worked for almost
eight months to restore the first rooms. Route 66 is very
famous and popular in Europe, and we are proud to live
on Route 66."

The Globetrotter Lodge offers guests a traditional
Route 66 motel experience, circa 1960s, but with an array
of custom touches. Guests also experience European
hospitality at the breakfast that is included in the price of
the room. Peter and Mona, and the Globetrotter Lodge,
represent the modern era on Route 66.

The renaissance of Route 66 has also sparked
interest in the highway's predecessor, the National Old
Trails Highway. With Route 66 between Holbrook and
Winslow truncated to a segment through Joseph City and
past the iconic Jack Rabbit Trading Post, enthusiasts are
discovering a near pristine segment of the National Old
Trails Highway between the two communities.

The highlight of this drive is the historic and scenic
Chevelon Canyon Bridge. Recently renovated by the
Arizona Department of Transportation, on October 2,
1912, this was the first bridge authorized by the newly
formed state legislature.

In the summer of 2015, the Historic Vehicle
Association outfitted a 1915 Ford Model T and set out to
commemorate Edsel Ford's trip from Detroit to California,
much of which was on the National Old Trails Highway.
The historic bridge provided an excellent setting for scenes
in the association's video and photo chronicle of the trip.

In each Route 66 community that becomes a
destination and behind the resurrection of each roadside
business is a person with vision who has the ability to
infuse others with their passion. In Pontiac, Illinois, it
is Bob Russell. In Atlanta, Illinois, it is Bill Thomas. In
Seligman, Arizona, it is Angel Delgadillo. In Winslow,
Arizona, it is Allan Affeldt, and his wife, Tina Mion, an
internationally acclaimed artist.

Affeldt came to Winslow from a diverse background
that included the organization of rock concerts and peace

walks in the former Soviet Union. "Our acquisition of the La Posada and relocating to Winslow was somewhat of an accident," he said. "We learned that the historic hotel was an endangered property with its listing as such by the National Trust for Historic Preservation. We visited the property in 1994 and decided to assist local preservationists to save it." At that time, there were plans for demolition.

This was the beginning of a three-year struggle that included negotiation with the railroad, the resolution of legal, environmental, and financial obstacles, and the establishment of La Posada LLC with Daniel Lutzick as general manager. Renovation was a daunting task as the restaurant had closed in 1956 and the hotel in 1959, and the railroad had transformed the facility into an office complex.

As it turned out, transformation of the derelict property into a world-renowned resort hotel was only the first step. Recently, a Tesla charging station was added to the property, as well as the largest privately owned solar power generating facility in the state of Arizona, which moved the hotel toward self-sufficiency and made it a showpiece of historical preservation. Plans call for the establishment of a vineyard and ornamental vegetable garden and the restoration of the former depot to house a Route 66 art museum.

As if the restoration of the hotel was not a large enough undertaking, Affedlt turned his attentions toward the revitalization and transformation of Winslow. He purchased and renovated the theater and served as mayor, while overseeing the updating of the city's charter and creating a balanced budget.

Surprisingly, the transformation of the Route 66 corridor in Winslow is still rather limited. While several blocks centering on the La Posada and Standing on the Corner Park now teem with visitors, and while there are plans for restoration of other properties, much of the area still appears as it did when the bypass of Route 66 decimated the historic business district.

In contrast to the La Posada, the ruins of the Two

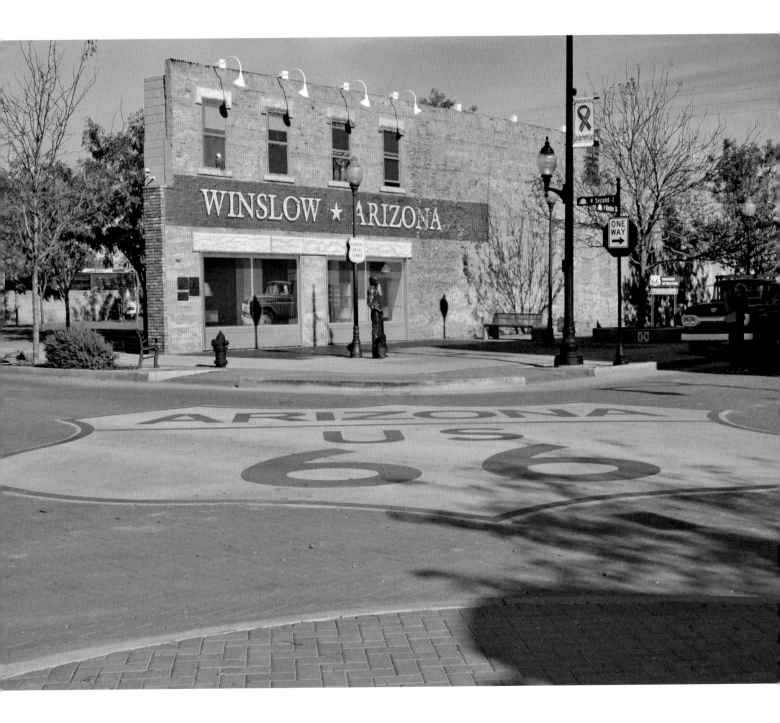

THE LAND OF OPPORTUNITY

Guns complex nestled along the rim of Diablo Canyon west of Meteor Crater are a surprising attraction. The stunning landscapes that frame the ruins account for only a smart part of the site's allure.

Shortly after construction of a bridge spanning the canyon for the National Old Trails Highway in 1915, Ed Randolph acquired several hundred acres along the canyon and established a complex that consisted of camping sites, a store, and, eventually, a service station. Shortly after Earl Cundriff acquired the property and transformed the business into Canyon Lodge in 1924, he leased some land to Harry "Indian" Miller who established a roadside zoo at the canyon.

Simmering disputes pertaining to property boundaries reached a crescendo on March 3, 1926, when Miller shot and killed Cundriff. After his acquittal, Miller relocated to the Lupton area, and established another trading post on the New Mexico side of the border.

Rimmy Jim Giddings was a colorful character that operated a trading post and gas station at Two Guns during the 1930s. Famous for practical jokes, Giddings trading post—marketed through window decals, souvenirs, and word of mouth—became an institution known the length of Route 66.

With realignment of Route 66, a new facility built on the north side of the canyon met the needs of travelers until 1971, when a devastating fire leveled most buildings. With the bypass of Route 66 by Interstate 40, a campground prospered for a short time as it was located at the highway exit. Today, however, it too is in ruins.

Even though Flagstaff has not embraced Route 66 fully, tourism remains a vital component in the city's economy resultant of its proximity to the Grand Canyon and numerous national monuments. This is not to say that Route 66–related sites are not plentiful or that they do not attract an array of enthusiasts, especially those traveling the route in its entirety.

The Museum Club is a roadhouse with a decades-long association with Route 66. The origin for Miz Zip's is Trixie's Diner, established in 1942. The Galaxy Diner opened in 1952.

ABOVE
The historic Partridge Creek Bridge near Ash Fork is the eastern end of the 160 Miles of Smiles marketed by the Route 66 Association of Kingman.

OPPOSITE
Miz Zip's in Flagstaff has been providing travelers and locals alike with hearty fare for more than sixty years.

BELOW
The resurgent interest in Route 66 has fueled modern development that mimics the past.

In Williams, even though it too depends heavily on its proximity to the Grand Canyon, especially as it serves as the terminus for the Grand Canyon Railway to fuel its tourism-based economy, Route 66 is an integral component to the community's year-round popularity. Restaurants, motels, bars, and gift shops, some in business for decades, successfully capitalize on their association with Route 66.

Ash Fork and Seligman make for an interesting case study. Drive the streets of Ash Fork lined with vintage auto courts, historic buildings, and empty shops, especially after driving from Chicago through towns such as Pontiac, Atlanta, Galena, and Williams, and you will be amazed that the town languishes. Though there are signs of a reawakening, such as the ongoing restoration of Zettler's Market, it is quite evident that the Route 66 renaissance, as with I-40, has bypassed the town.

Seligman is the exact opposite, largely resultant of the efforts of the Delgadillo family, and people such as Frank and Lynn Kocevar, former owners of Seligman Sundries and active Route 66 promoters. On any given day, especially during the peak season between April and October, the traffic and throngs of people present the impression that Route 66 is still the Main Street of America from Chicago to Santa Monica.

That popularity, however, represents a new type of threat to Route 66 communities. Underlying the international fascination with Route 66 is a quest for an authentic American experience, or at least the perception of such an experience. Communities can embrace the resurgent interest in Route 66 with such a passion that they lose sight of that fact. As a result, they become an imitation of Disneyland, which in turn can lead enthusiasts to stop for a T-shirt or cold drink before they seek a destination that provides them with an opportunity to experience the romanticized image of the Route 66 experience.

Almost universally, enthusiasts consider Seligman to be the birthplace of the Route 66 renaissance movement. With completion of the I-40 bypass in 1978, the town entered a period of precipitous economic decline. The town barber, Angel Delgadillo, initiated a meeting of local business owners at the Copper Cart restaurant to address

the issue. This fledging gathering of concerned citizens evolved into the Historic Route 66 Association of Arizona, the first state Route 66 association, in 1987, and a lobbying initiative that resulted in the Arizona state legislature designating US 66 in Arizona as a historic highway.

Today, Delgadillo's barbershop and gift shop is a destination for tens of thousands of international enthusiasts annually. Arguably, as enthusiasts individually or by the busload stop at the shop for a haircut or to shake Delgadillo's hand, this is the most famous location anywhere on Route 66.

Seligman is where the annual Route 66 Fun Run, held on the first weekend in May, begins. Dating to the late 1980s, this is one of the oldest Route 66 festivals, and it continues to grow in popularity and scope. Since its inception, it has spawned numerous imitators and fueled international interest in Route 66.

Canadians Bob Walker and Lorrie Fleming were traveling west on I-40 after a visit to Santa Fe in 1994 when they noticed a sign indicating that the next exit was for Historic Route 66. Memories of the classic television program staring George Maharis and Martin Milner led them to make a detour that was to have rather dramatic implications.

Lorrie Fleming said, "We stopped in the sleepy little hamlet of Seligman and, much to our surprise, were

ABOVE
Peach Springs is the capital of the Hualapai Reservation that stretches north to the rim of the Grand Canyon.

RIGHT
Flags representing every country of visitors with a notation in the guestbook fly at the entrance to Grand Canyon Caverns.

OPPOSITE
The annual Route 66 Fun Run transforms the 160-mile highway corridor in western Arizona into a living time capsule.

ABOVE
The recently refurbished Grand Canyon Caverns Inn provides visitors with an authentic circa-1960s experience.

LEFT
The sense of whimsy that was an integral part of the Route 66 experience decades ago continues at the Grand Canyon Caverns.

OPPOSITE
West of Seligman, vestiges of the National Old Trails Highway remain.

greeted by Angel Delgadillo, the town barber who is credited in forming the Historic Route 66 Association of Arizona and pioneering the historic highway movement to 'Save the Mother Road.' Angel convinced us to come back the following year for the Fun Run.

"He was so enthusiastic and convincing that we returned in April 1995 sporting our 1982 Corvette and officially registered for his spectacular event. We were the only Canadians, albeit there were lots of participants present from other countries. We had so much fun that we planned our vacation here the following year."

The Canadian Route 66 Association was born of Walker and Fleming's detour inspired by a television program. Today, the Canadian Route 66 Association is well represented each year at the annual Route 66 Fun Run. Recently, an Australian-based company began including the event in its spring Route 66 tour, and in 2016, a New Zealand–based company also added the event to its tour.

Route 66 from the historic Partridge Creek Bridge accessed via the Crookton Road exit on I-40 to Topock on the Colorado River is the longest remaining uninterrupted segment of the highway. It is also one of the most scenic, especially the pre-1952 alignment through the Black Mountains.

Officially, the distance between the two points is 158 miles (254 kilometers). However, by driving older segments of the highway such as Chadwick Drive in Kingman, the distance will vary. The Route 66 Association of Kingman, working with Ramada Kingman, the city's only full-service Route 66 resort housed in a former Holiday Inn complex built in the 1960s, initiated a marketing campaign entitled 160 Miles of Smiles in 2015.

"Never judge a book by its cover" is an old adage easily applied to many places scattered along Route 66. However, there are few places where it is more fitting than Grand Canyon Caverns west of Seligman, one of the crown jewels on this section of Route 66 in western Arizona. The caverns, as locals refer to the resort, is a microcosm of Route 66 evolution from inception to renaissance. As with the old road itself, the past and future flow together seamlessly here.

The gaily painted sign and flags from more than a dozen countries waving in the gentle breeze beckon the traveler to stop. However, after entering the property, the first impression is that this was once a grand roadside resort now fallen on hard times.

Scattered about the parking lot and around the old service station, an eclectic array of derelict vehicles serve as props for photographers. In the building that houses the motel's front desk, a former restaurant where overnight guests are provided with a free breakfast is peppered with an interesting array of artifacts from another time—a collection of Pez dispensers, a couple of old pinball machines, and a wall adorned with brands from area ranches. The building also contains a lounge, refurbished and open for groups; a mini-mart; and a fascinating but small museum where tangible links to the resort's ninety-year history are intermingled with vestiges of American societal evolution during that same period.

The bright green brontosaurus that dominates the hill overlooking the golf cart graveyard and rusty dinosaur sculptures surrounding the nine-hole miniature golf course seems oddly out of place. It appears new and fresh. However, in actuality, this big green beast is rather symbolic. As John McEnulty, resort owner, noted during a recent visit, "We are trying to make everything we have look like brand new, circa 1964, our target year. We do upgrades to all of the 'guts' of the place, new queen and

king beds, flat-screen televisions, but we want to keep the look of the mid-1960s when the property was at its zenith."

In discussing his association and acquisition of the property, McEnulty said, "I have been taking the caverns' tours since 1967 as part of hiking trips into Supai or Grand Canyon National Park. In the beginning, it was one crazy busy place until I-40 bypassed this section of Route 66. Once bypassed, this huge place was like a ghost town. It seemed so odd, so unfair."

"In late 2000 my brother Frank called to say that my favorite place was for sale. I knew what place he meant. We decided to form a group to buy and restore it, and I started coming there almost every week in 2001.

"Initially, the Ringsby family that had owned the property since 1956 did not want to sell to us as they were absentee owners at this point, and we were from

BELOW
In Peach Springs, traditional Native American themes receive a modern touch.

OPPOSITE
In the summer of 2015, the Historic Vehicle Association re-created Edsel Ford's journey along the National Old Trails Highway to celebrate a century of road trips.

California. When they realized I was on site every week, a decision was made to sell, and in April 2002, we closed on the property.

"We have spent more than we hoped and taken longer than we thought, but Grand Canyon Caverns is starting to look and feel like its Mother Road glory days, and visitor counts, as well as how long they linger, are greatly increased. It has been a good journey, and we did something truly worthy along Route 66."

When asked about plans for the property, McEnulty said, "With fourteen hundred acres we can dream big, including new cavern tours scheduled for spring 2016, and an annual music festival. We are also developing partnerships with other Route 66 businesses, including Keepers of the Wild, Bearizona, and Grand Canyon Railway."

Another unique aspect of the caverns' property is tangible links to the National Old Trails Highway that predated Route 66. Nestled in a cedar-studded canyon immediately to the east of the caverns' original entrance are stone retaining walls, culverts, and bridge supports, vestiges of that pioneering highway.

This would be the road followed by Edsel Ford in the summer of 1915 as he and friends journeyed west from Detroit to the Panama-Pacific Exposition in San Francisco via the Painted Desert and the Grand Canyon.

This is an excerpt from Ford's journal, detailing his visit to this area: "Williams, Arizona, Thursday July 15, 1915—Found Cadillac and Stutz crews at Harvey Hotel at Williams waiting for us. All got supplies at garage. Talked to Ford Agent. Got going about eleven. Had lunch at Ash Forks [sic]. Loafed along; found it very hot. Bought some gas and oranges at Seligman. Stutz broke another spring about 15 miles out and returned to Seligman. Cadillac and Ford went on to Kingman, arriving at midnight, Brunswick Hotel. Very rough and dusty roads. Wired Los Angeles Branch for axle parts. Day's run 146 miles."

As an attraction, the caverns themselves date to 1927, a few months after certification for US 66. Legend has it that Walter Peck, an itinerant cowboy and woodcutter for the Santa Fe Railway, was taking a shortcut to a local poker game when he stumbled on, and

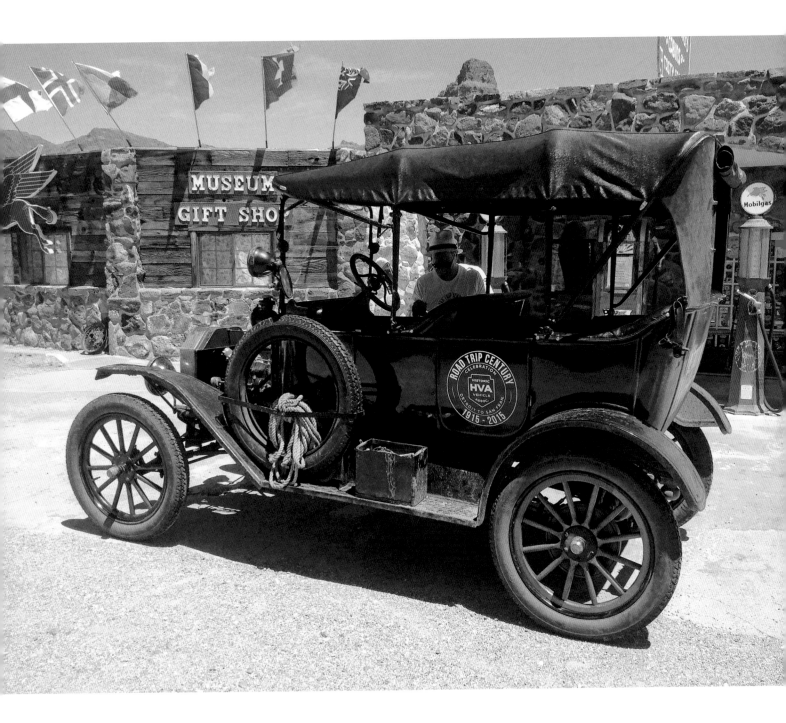

THE LAND OF OPPORTUNITY

almost into, the entrance of the cave. Peck, however, told a different tale.

"I was going along by myself when I flushed a bobcat. I run after him a few yards just for fun, and dogged if I didn't come onto a big funnel-shaped hole washed out right there on the flat of the earth. I couldn't see no reason for no hole to be there, so I forgot the cat and edged over to it, trying to peek down. It was scary—you know, like a doodlebug funnel in the sand that traps ants for the bug to catch and eat down at the bottom," he wrote.

After an initial exploration of the cavern with friends from the railroad, and the discovery of two skeletons on a rocky shelf below the entrance, Peck decided to capitalize on his discovery. After securing

a lease for the property, he commenced extensive exploration of the caverns in the hope of finding gold, silver, or treasure. At the time, he did not realize that the treasure he sought was in the pockets of tourists traveling Route 66.

Using the "prehistoric skeletons" as the hook, and the hand-operated winch he had built on the rim of the opening, for ten cents, later a quarter, he would provide curious tourists with a lantern and lower them into the Yampai Cavern. Among friends, he dubbed this *dope on a rope*. A replica of his contraption stands in front of the caverns' visitor center and restaurant.

The use of the skeletons to promote the attraction invoked the ire of the Hualapai tribe, as the bodies were two

woodcutters placed in the caverns a decade before during a hard winter that left the ground too frozen for burial. The dispute merely fueled the notoriety of the caverns.

Profits, however, remained elusive. Still, throughout the 1930s, improvements were made to enhance the tour experience. In 1936, the Civilian Conservation Corps—utilizing materials from the Hoover Dam project, including forms used for concrete—built a proper entrance into the caverns that included stairs, ladders, and a swinging bridge.

Peck gave up on the caverns in about 1937 and Stan Wakefield, who also owned Deer Lodge, became the next caretaker of the caverns. Wakefield did little to improve the caverns, but he did initiate and develop extensive promotion that included a showcase of oddities found in the caverns, such as the saddles originally found with the skeletons and construction of a "caveman's living room" at Deer Lodge.

Surprisingly, the caverns did not receive mention in the now classic book *A Guide to Highway 66* published and written by Jack Rittenhouse in 1946. However, he did mention Deer Lodge and Hyde Park located along the highway on the opposite side of the hill from the caverns: "Deer Lodge cabins and gas. At 206 miles is Hyde Park, offering a café, gas, and cabins."

Throughout the golden years of Route 66 in the early to mid-1950s, the caverns continued to evolve as an attraction rather slowly and the name changed to Coconino Cavern. Published in February 1960, *A Detailed Report of Coconino Cavern, Outlining Geographic Features* by Winton F. Wright detailed a few of the improvements made since August 1940.

The most notable of these was a nineteen-flight steel staircase that replaced the wooden ladders and stairs, completion of an elevator shaft, and paved trails. As an interesting footnote, the elevator, not yet installed at the time of the report, was obtained from a demolition project in Phoenix, while the steel staircase was a fire escape acquired during the demolition of a building in New York City.

The year before the publication of the report, a major discovery made at the caverns catapulted it into the international media spotlight. Winston Wright described

the discovery in 1960: "I chanced, one day, near the east wall, to come upon some bones stretched out on the floor, of the cavern, on top of the rocks. I felt certain that they were the remains of a prehistoric animal of large size, with immense claws."

Scientists from the University of Arizona at Tucson examined the find in September 1959 and identified the remains as being from a fifteen-foot (4.6-meter) prehistoric ground sloth. A replica of the creature and the claw marks on the wall made as it tried to escape are favorite stops on the caverns tour today.

This was the dawn of a new era at the caverns. Shortly after installation of the elevator by J. B. Ehrsam & Sons Manufacturing Company of Kansas City, the newly

formed Dinosaur Caverns Incorporated assumed control of the property. The primary investors in this company, J. W. Ringsby and his sons Gary and Don, trucking magnates, dreamed big.

After changing the name to Dinosaur Caverns, they initiated a major marketing campaign: "Look for the sign of a caveman leading a Brontosaurus" and "See a world created when Northern Arizona was a steaming jungle." Promotion, however, was just the first step in a visionary plan to build a dinosaur city and dinosaur park.

In 1961, Architect Charles D. Hoyt finished the Dinosaur Caverns Visitor Center, a facility that appears unchanged today. The revamped caverns and visitor center officially opened with a lavish dedication ceremony on May 12, 1962, with Thomas Miller, former director at Mammoth Cave National Park, presiding as supervisor.

During the same period, two unrelated incidents provided additional promotional fodder. One was the debut of the animated television program *The Flintstones* in September 1960. The second was the Cuban Missile Crisis, the designation of the caverns as a fallout shelter, and its stocking with supplies for two thousand people for two weeks. These supplies, still in pristine condition, are another attraction that makes a caverns tour unique.

In 1963, the motel opened, and the complex expansion commenced in earnest. Thomas Miller completed the trail system and made another discovery in the process, a desiccated almost perfectly preserved bobcat resultant of the constant fifty-six-degree temperatures, low humidity, and bacteria-free environment.

Next to the Grand Canyon itself, this was the most visited attraction in the state of Arizona. Indicative of its growing prominence as an attraction is the four-lane segment of highway at the entrance to the property; aside from urban corridors in communities such as Williams and Winslow, this was the only multiple-lane segment of Route 66 between Albuquerque and Los Angeles.

Even though business was booming, the vision faded. Dinosaur Estates with streets named Ledgerock Lane, Sabertooth Drive, and Fossil Court never materialized. Neither did plans to construct a huge dinosaur "under" Route 66 with its head on one side and tail on the other.

Today, John, with the help of his son Sean, is breathing new life into the caverns and infusing the site with a vibrant spirit. The caverns are in fact on the cusp of becoming the full-fledged resort envisioned in the 1960s.

The renovation of the motel, the recent discovery of new levels in the caverns, trail rides, wagon rides, a disc golf course, ghost walk tours in search of Walter Peck, and the quirky but challenging miniature golf course among the towering dinosaurs are recent manifestations of McEnulty's vision for the future of the caverns. Likewise, with the fully updated and renovated RV park that recently garnered accolades from Good Sam, or the Caverns Suite, the world's deepest hotel room.

The caverns, Keepers of the Wild, Desert Diamond Distillery at the Kingman Airport Industrial Park (formerly the Kingman Army Airfield during World War II), Cool Springs, Topock Resort, and Stetson Winery are manifestations of how the revived interest in Route 66 is restoring a sense of vitality along the highway corridor in western Arizona. Likewise, with the Route 66 Electric Vehicle Museum housed in the Powerhouse Visitor Center in Kingman, the first museum of its kind in the world, and the Route 66 Association of Kingman's initiative to restore and replace neon signs throughout the historic district.

At the 2014 Route 66 International Festival held in Kingman, there was a formal dedication for the Route 66 Walk of Fame. Conceived as a means to honor the individuals who contribute, or have contributed, to the transformation of this highway into an icon, new inductees are added each year during the Best of the West on 66 Festival. This festival blends Kingman's western history with events such as a PRCA rodeo as well as traditional Route 66 events and a parade.

In 2016, Dries and Marion Bessels of the Dutch Route 66 Association and walk of fame inductees in 2015 served as the grand marshals for the festivals parade. The official invitation was presented at the first European Route 66 Festival in Germany.

ABOVE

The refurbished neon sign for the Kingman Club is one manifestation of the revitalization that is transforming the historic district in Kingman.

RIGHT

In addition to an award-winning Route 66 museum and the gift shop for the Historic Route 66 Association of Arizona, the historic Powerhouse Visitor Center in Kingman also houses the Route 66 Electric Vehicle Museum.

To date, the surprisingly modest walk of fame includes Zdnek Jurasek and his wife Eva, founders of the Czech Route 66 Association; Angel Delgadillo; Bob Waldmire; Michael Wallace; Dale and Kristi-Anne Butel of Australian-based Route 66 Tours; and Dries and Marion Bessels, founders of the Dutch Route 66 Association.

There are also classic sites such as the "ghost town" of Oatman, the Hackberry General Store, the Hill Top Motel, and El Trovatore Motel. This 1939 resort complex dominated by a neon tower recently refurbished by the property's new owners, Sam and Monica Frisher, is another manifestation of historic preservation spurred by the resurgent interest in the highway.

Intertwined with these landmarks and historic sites are the stunning, rugged landscapes and vast desert plains. In the Black Mountains along the pre-1952 alignment of Route 66, the sharpest curves and steepest grades of the highway make for some thrilling driving and provide spectacular views.

In Rittenhouse's *A Guide Book to Highway 66*, the author noted, "Now you start up the Gold Hill Grade, possibly the steepest grade you will encounter on US 66. The east side of this grade rises 1,400 feet (427 meters) in nine miles (14 kilometers), starting with a long, gentle slope and becoming more difficult as you near the summit. The west side of this grade is the steepest but will present no problem to the westbound driver, who should, however, keep his car in second gear going down."

Rittenhouse also noted, "For eastbound cars that cannot make the Gold Hill Grade, a filling station in Goldroad offers a tow truck that will haul your car to the summit. At last inquiry their charge was $3.50, but may be higher."

That garage belonged to N. R. Dunton. It was also the cornerstone for the building of a desert empire. Roy Dunton said, "My uncle, N. R., came to White Hills, Arizona, for a job as a teamster, but it fell through. While hitchhiking back to California, he landed a job at a garage and service station in Goldroad. That was in the 1920s. Seeing the potential in the property and learning that it was for sale, he went home, borrowed money from relatives, returned, and bought the garage. In addition to the garage, he built Cool Springs in 1926."

Roy continued, "I was working in Spokane in 1937 when my uncle visited and offered me work in Goldroad." In 1946, with a partner, N. R. Dunton established Biddulph & Dunton, a Ford, Mercury, Lincoln dealership in Kingman on Route 66. Roy later acquired the facility and successfully kept it afloat as an Edsel dealership before converting it to a full-service General Motors franchise.

Under the management of his son Scott, the facility is now a classic car dealership and restoration garage. Scott is also the president of the Route 66 Association of Kingman and that organization's office is at the historic dealership as well.

Next door is the historic Kimo Café that dates to the late 1930s. After acquiring the property in the early 1990s, the Dunton family transformed it into a modern classic, Mr. D'z Route 66 Diner (the "D" is in reference to Roy Dunton).

All of these scenic wonders and historic sites, coupled with innovative initiatives and the development of cooperative partnerships in Kingman along the corridor that constitutes the "160 Miles of Smiles," have the potential to transform the area into a major destination for Route 66 enthusiasts and to introduce the allure of Route 66 to those unfamiliar with the highway's renaissance.

OPPOSITE TOP
The Biddulph & Dunton Motors facility established in 1946 provides visitors with another opportunity to step back in time in Kingman.

OPPOSITE LEFT
The pre-1952 alignment of Route 66 west of Kingman in the Black Mountains was also the course for the National Old Trails Highway.

OPPOSITE RIGHT
Traditional Hualapai dancers perform at the Powerhouse Visitor Center twice each week.

THE END OF THE TRAIL

Route 66 in California is a study in contrasts. The highway traverses a vast desert wilderness as well as a vibrant urban metropolis. It courses through sun-bleached ghost towns and a string of traffic-congested communities that stretch from the foot of Cajon Pass to the shores of the Pacific at Santa Monica.

Cinematic history and a few interesting photo opportunities are the solace for having to cross into California on Interstate 40. In the classic movie *Easy Rider*, Peter Fonda crosses the Colorado River on the eastbound bridge for the interstate that was also the last bridge to carry Route 66 traffic.

The first bridge to carry Route 66 traffic across the river is the scenic, graceful arch of the National Old Trails Highway Bridge that now serves as support for pipelines. Built in 1916, the bridge carried traffic until 1947. In the 1940 film adaptation of *The Grapes of Wrath*, Henry Fonda enters California on this bridge.

At the Park Moabi Road exit, it is possible to access the early alignment of Route 66 and view the historic bridge from the California side of the river. However, I-40 construction has severed both ends of this highway segment.

For a variety of reasons, Needles, the first Route 66 community in California, has yet to harness or even embrace the Route 66 revival. This coupled with the fact that the neighboring Bullhead City/Laughlin area and Lake Havasu City have been the focal point of development in recent years has resulted in slow but steady decline since the bypass of Route 66. As a result,

ABOVE
Marooned on a truncated alignment of Route 66 on the California side of the Colorado River is this sign that dates to the 1930s.

OPPOSITE
The El Rancho Motel in Barstow was constructed from used railroad ties.

Still, a few individuals work to keep the community alive with passion and zeal and to reverse this trend. In early 2016, a series of new billboards for the I-40 corridor were unveiled that hint of the town's association with Charles Schultz, creator of the beloved *Peanuts* cartoons.

Route 66 followed two distinctly different courses west from Needles as it climbed from the Colorado River Valley and into the forbidding Mojave Desert. The post-1931 alignment lies buried under I-40 to the Mountain Springs Road exit. Accessed via the US Highway 95 exit is the early alignment that followed the National Old Trails Highway and Arrowhead Highway though Goffs and Fenner before rejoining the newer alignment at Essex. This would be the road followed by Edsel Ford, Barney Oldfield, and Louis Chevrolet in the teens.

In his journal dated July 18, 1915, Edsel Ford wrote, "Started west from Needles at 6:15 p.m. in procession of eight cars—a Jeffery, two Fords, two Chalmers, two Stutz, and a Cadillac. Thirty miles out Chalmers broke a spring. Roads in desert were fair. Stopped for midnight lunch. Played phonograph, fixed a tire. Stopped at Ludlow for gas, had to wake up the Desert Queen to get it."

Surprisingly, the remote and forlorn community of Goffs is home to a diverse museum complex that is world class in caliber. The Mojave Desert Heritage Cultural Association established by Dennis and Jo Ann Casiber

includes the refurbished 1914 school that houses an extensive collection of artifacts, including remnants from World War II when this area was a part of General Patton's sprawling training facility in preparation for the invasion of North Africa. Also displayed on the expansive grounds are railroad items as well as an operational ten-stamp mill.

From Essex to Amboy, Route 66 closed for quite some time after flooding in 2014 damaged numerous bridges. This and the fact that all of the 135 bridges on Route 66 in the Mojave Desert east of Barstow are overdue for replacement is indicative of the challenges associated with ensuring the road remains viable into its centennial.

It is difficult for states to give priority to repairs of roads such as this when there are more pressing and relevant needs. Compounding the problem in remote locations is the fact that even the economic benefits of tourism are limited as well as difficult to quantify.

Of all the faded or abandoned communities in the desert—Goffs, Fenner, Essex, Chambless, Amboy, Bagdad, Ludlow, Newberry Springs, and Daggett—only Amboy holds the glimmer of promise that the resurgent interest in Route 66 might lead to a bit of revival.

The once-thriving community where cafés, garages, and service stations operated twenty-four hours per day, seven days per week, transitioned into a ghost town within twenty-four hours in 1973. As Buster Burris, primary business owner at the time noted in an interview, "It was like somebody put a gate across Route 66. The traffic just plain stopped. That very first day it went from being almost bumper to bumper to about a half-dozen cars."

Shortly afterward, Burris bulldozed numerous buildings and business to avoid tax liabilities. Today, a service station (still in business), a long-closed school, a post office, a few houses, an abandoned church, and the former Roy's Café and Motel, also closed, are the primary structures remaining.

However, restaurant entrepreneur Albert Okura recently purchased almost the entire town site and has plans for transforming it into a destination. An array of setbacks has delayed these plans, but Amboy remains a favored photo stop for enthusiasts.

ABOVE
For early motorists, the vast wilderness of the Mojave Desert presented a formidable obstacle.

RIGHT
Before Route 66, travelers followed the National Old Trails Highway across the Mojave Desert and through towns such as Ludlow.

OPPOSITE
Scattered all along the Route 66 corridors in Needles are tarnished relics and dusty gems.

Before the interstate highway, each of these remote communities, some of which never consisted of more than a service station, repair facility, and café, provided valuable and occasional life-saving services. They also provided jobs and prosperity, especially for the owners. In the previously noted interview, Burris noted, "I had ninety people working for me full time. During the summer, the number of workers could get as high as a hundred and twenty."

Mark Nowning said this about his experiences working in a Ludlow garage during the mid-1960s: "Life in Ludlow was twelve-hour work days, six days per week, at a buck twenty-five per hour, no overtime. Rent of a small house trailer and utilities were included in the pay so when we got paid it was all ours, such as it was.

"We didn't think much about it at the time. I liked it there, lots of solitude," he continued. "It was the time of the great hippie migration to San Francisco so that was pretty entertaining, even had a small run in with Charley Manson before he became infamous."

In discussing the owners of businesses and the prevailing attitude of residents in the little desert villages, little had changed from the era of the Okie migration of the 1930s. Nowning noted, "The people that owned all those little towns were pretty much in it for the money, not much mercy for the flat-broke or broke-down travelers, and if the employees did anything to help them, it was a firing offense, as my dad found out. And when you got fired, you were also immediately homeless.

"I learned many lessons there; short-change artists took me for a few days' pay, gas and goes; gypsies, tramps, and thieves all got a few of my hard-earned dollars. After a while you learned to not trust anyone," Nowning said. "One young couple came in the gas station where I was working, they had small children in the car, and said they were broke and wondered if I could give them a few bucks so the kids could eat. I felt sorry for the kids so I gave them five bucks, which was a half day's pay. He came out of the café with a couple packs of smokes, and a sixer of beer, held them up so I could see what he bought with my money, yelled sucker, and peeled on out of there."

Nowning continued, "But mostly there, as with everywhere, the majority of people were just trying to get by and get to where they were going."

In the past, travelers often drove by night to avoid the heat, and this provided additional opportunities for business owners. As an example, motels to the east and west of the desert offered special daytime rates. Surprisingly, today, even though summer temperatures often exceed 120 degrees Fahrenheit (49°C), the months of summer are the primary time for travel on Route 66 in the Mojave Desert.

The sense of timelessness that comes with travel across the desert on Route 66 is rather fitting in

consideration of the rich and colorful history found along the highway corridor. Father Francisco Garces noted that the springs at modern-day Newberry Springs were a desert oasis in his expedition journal from 1776. Even this, however, is relatively recent history as there is archaeological evidence that settlement at the springs spans several thousand years.

The Mojave Trail followed some of the course for what is Route 66 and I-40 today. Before establishment of the railroad in the 1880s, this was the primary transportation corridor across the desert.

The Desert Market in Daggett opened in 1908 as Ryerson's General Store. The long-closed Stone Hotel dates to at least 1885 and has a direct association with John Muir as well Walter Scott, better known as Death Valley Scotty.

In 1905, Ludlow was a prosperous railroad community. In addition to the main line that connected Los Angeles with Chicago, this was also the junction for spur lines to area mining camps as well as the Tonopah & Tidewater Railroad linked to mining towns in Nevada.

The junction of I-15 and I-40, and the Marine Corps base, has ensured that Barstow maintains economic vitality even though the historic business district has faded greatly since the bypass of Route 66. For Route 66 enthusiasts, the town is known for the critically acclaimed Route 66 Mother Road Museum complex housed in the stunning Casa del Desierto, a former railroad depot and hotel complex built between 1909 to 1910.

From Barstow, it is possible to follow Route 66 into Victorville, and along some segments through the Cajon Pass. For the most part, this is also the course of five historic roads.

Surviving businesses with a direct link to the pre-interstate highway era of Route 66 are relatively scarce along this section. Even the relics and ruins are vanishing at a rather rapid space. There are, however, a few exceptions, a few of which are revered.

The 1930 Mojave River Bridge is one. Another is the ragged-looking Emma Jean's Holland Burger in Victorville that continues to serve excellent traditional American diner fare as it has since opening in 1947.

Victorville is also home to the California Route 66 Museum and the well-worn Green Spot Motel, now a budget apartment complex that rents rooms by the week or month. The latter was once part of a complex that included a lounge and restaurant.

From the late 1930s into the mid-1950s, when Victorville served as an extension of Hollywood for the

ABOVE
The communities along Route 66 between Barstow and Victorville have faded rather dramatically since completion of the interstate highway.

OPPOSITE
The uniquely styled Barstow Harvey House is a landmark as well as a destination.

BARSTOW HARVEY HOUSE

HARVEY HOUSES WERE LEGENDARY IN THE HISTORY OF WESTERN RAIL TRAVEL. OPERATED BY FRED HARVEY IN CONJUNCTION WITH THE SANTA FE RAILWAY, THE NETWORK OF RESTAURANT-HOTELS SET A NEW STANDARD IN QUALITY MEAL SERVICE. BARSTOW'S SPANISH-MOORISH "CASA DEL DESIERTO", OPENED IN 1911 AND CLOSED IN 1971. IT WAS REGISTERED AS ONE OF THE LAST AND FINEST REMAINING EXAMPLES OF THE WEST'S FAMOUS HARVEY HOUSES.

CALIFORNIA REGISTERED HISTORICAL LANDMARK NO. 892

PLAQUE PLACED BY THE STATE DEPARTMENT OF PARKS AND RECREATION IN COOPERATION WITH BILLY HOLCOMB CHAPTER OF E CLAMPUS VITUS, MOJAVE RIVER VALLEY MUSEUM, SAN BERNARDINO COUNTY MUSEUM, AND FRED HARVEY, INC., MAY 1, 1963.

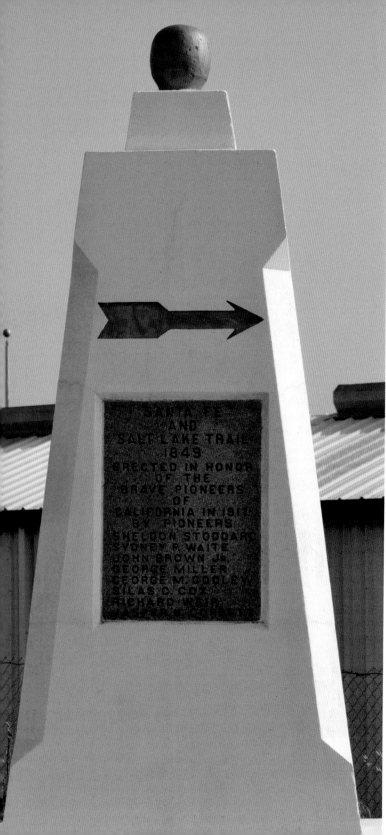

filming of movies as well as television programs in the surrounding deserts, this was a haven for celebrities looking for a weekend escape, and a home away from home for working stars. John Houseman and Herman J. Mankiewicz were guests here as they wrote the first draft of the script for *Citizen Kane*.

For centuries, the narrow confines of the Cajon Pass have served as the gateway between the high desert and the coastal plains now dominated by the metropolitan area. American Indian trade routes, as well as historic roads such as the Spanish Trail, Mormon Trail, Mojave Road, Arrowhead Highway, and National Old Trails Highway, have all utilized the pass, likewise with the railroad, US 66, and now Interstate 15.

Vestiges from all of the historic roads remain, but the modern incarnation of these historic roadways, the interstate highway, has transformed them into truncated and severed segments, many of which are difficult or impossible to access. Infrastructure has not fared even this well.

The Summit Inn and Café located at the top of Cajon Pass dated to 1952. However, it was a replacement for an earlier facility razed during transformation and realignment of Route 66. At the time of the Summit Inn's reconstruction (built by Gordon Fields for Burton and Dorothy Riley), US 66 was a two-lane highway on the east side of the property. With transformation to a four-lane highway, the Summit Inn was located on the west side of the highway. In 2016, the rebuilt Summit Inn was destroyed by the Cajon Pass fire that summer.

Between the Cleghorn Road, Exit 129, and Kenwood Avenue, Exit 124, is a rare opportunity to experience Route 66 in the Cajon Pass. Here are segments of two- and four-lane alignments of the highway in landscapes contorted by the infamous San Andreas Fault and some picturesque vintage bridges. Observant travelers will notice remnants of earlier alignments.

Arguably, the alignments of Route 66 that course through the greater Los Angeles metropolitan area from the foot of Cajon Pass to the highway's original terminus at Seventh Street and Broadway in Los Angeles, and westward to the latter terminus in Santa Monica, are, surprisingly, the least-explored portion of this highway. As with all of the metropolitan areas that Route 66 passes through, crime, real and perceived, and traffic are the biggest deterrent. The *EZ 66 Guide for Travelers* by Jerry McClanahan, the most popular guidebook for Route 66 enthusiasts, notes that it is seventy-six miles (122 kilometers) from San Bernardino to Santa Monica on Route 66, and to drive this will require three hours or more.

Historian, tour guide, and principle organizer of the 2016 Los Angeles International Route 66 Festival, a ninetieth anniversary celebration, Scott Piotrowski said, "Route 66 has been neglected for so long in Los Angeles, and so there is a lot of work to be done. For starters, we really need to have the Route 66 community understand what we have to offer them, and all of the amazing landmarks related to the road that travelers have to see along 66 in Los Angeles. Until the Route 66 community acknowledges our Route 66 history, it will be hard to persuade travelers to take the time to see our eighty-seven National Register of Historic Places Landmarks in the Route 66 corridor in Los Angeles.

"But this is a double-edged sword," he continued. "How can I expect Route 66 travelers to come to a city to see Mother Road sights when those in the city don't even know about the road? The reality is that both of those things need to improve in tandem. While continuing to promote 66 in Los Angeles, I am hoping to do that—much like the road—in a bidirectional manner. The idea of the 2016 Los Angeles International Route 66 Festival really came out of that bidirectional need of information flow."

Exploring this urban wonderland, for those who have the patience for what may appear as an endless stream of stoplights and brake lights can be a grand adventure that borders on the epic. I should note that there is a secondary option for exploring much of Route 66—at least from the area of Monrovia to downtown Los Angeles, and in late 2016, to Santa Monica—and that is light rail. That option in itself makes a Route 66 adventure in this metropolitan area unique.

I strongly suggest Saturday and Sunday, as early in

ABOVE
In San Bernardino, the Route 66 corridor takes on a distinctly urban feel.

BELOW
Traveling Route 66 on the weekends is the best time for avoiding the notorious crush of traffic in the Los Angeles metropolitan area and in surrounding communities.

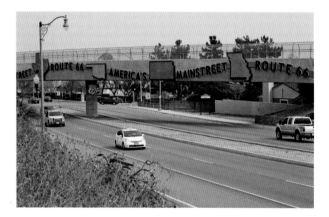

the morning as possible, for exploration. Traffic along the Route 66 corridor is surprisingly light, with the exception of Santa Monica Boulevard.

The urban adventure begins in San Bernardino where you have, at the site of the very first McDonalds restaurant on the corner of E and Fourteenth Streets, an early alignment of Route 66, the McDonalds Museum. East of Mount Vernon, another alignment of Route 66, on Fifth Street is a Route 66 Museum established by Albert Okura, founder of the Juan Pollo restaurant chain and the owner of most of Amboy.

At 602 North Mount Vernon is the Mitla Café. This dusty little gem has been providing travelers and locals with good food at reasonable prices since 1937. Downtown is the California Theater, an architectural masterpiece built in 1928.

Following Route 66 west along Foothill Boulevard, immediately to the east of the Rialto city limits, is the fully refurbished Wigwam Motel built in 1949. The Patel family has polished what once was a diamond in the rough to a brilliant sheen.

Intermixed with modern shopping centers, strip malls, quickie marts, and apartment complexes along Foothill Boulevard through Rialto and into Fontana are an unexpected array of old motels and auto courts, most of which now serve as low-rent apartment complexes and diners. Many face an uncertain future as the value of the property itself soars. Hope that they will survive to the highway's centennial and beyond is in the awakening preservationist movement along this section of the Route 66 corridor.

In early 2013, the Route 66 Inland Empire California Association, a nonprofit organization, acquired the Cucamonga Richfield service station and garage in Rancho Cucamonga, a facility that dated to 1915 and that retained most of its original architectural elements. While the garage itself had deteriorated beyond the point of feasible salvage, the station reopened in 2015 as a visitor center, and the plans are to re-create the garage as an event center.

The restoration was an exhausting and expensive endeavor. Foundations and footings had to be replaced under the existing walls.

ABOVE
Colorful signage ensures travelers can stay on course while following Route 66 through the greater metropolitan Los Angeles area.

RIGHT
Surprisingly, a number of 1950s- and 1960s-era motels and restaurants survive along Foothill Boulevard west of Pasadena.

ABOVE

The Madonna of the Trail statue in Upland is one of two on Route 66. The second is located in Albuquerque.

ABOVE LEFT

Even though much of the Route 66 corridor between San Bernardino and Pasadena is bordered by strip malls, communities proudly promote their association with that highway.

LEFT

Dating to 1848, the Sycamore Inn often is proclaimed the oldest restaurant on Route 66.

OPPOSITE

The 1915 Cucamonga Service Station seems oddly out of place in contrast to its modern surroundings.

Two other landmarks of note in Rancho Cucamonga are the Magic Lamp Inn and the Sycamore Inn, built in 1848, purportedly the oldest restaurant on Route 66 that has origins as a stage station for the Butterfield Overland Company.

Much of the complex was heavily damaged in a 1912 fire. An extensive remodel and renovation by owner John Klusman transformed the property by presenting a European look.

The Magic Lamp Inn at 8189 Foothill Boulevard opened in 1940 as Lucy and John's Café. After the sale of the property to Frank and Edith Penn in 1955, an extensive remodel transformed the restaurant with the addition of stained-glass windows and an *Arabian Nights* theme.

Because of urban congestion, the communities along the Route 66 corridor flow together almost seamlessly here. While most remnants that provide a tangible link with Route 66 in Upland have vanished, the city has revitalized much of the highway's corridor with landscaping and façade décor that presents an illusion of age.

Here, too, interesting landmarks await discovery. At the intersection with Euclid Avenue is a small park dominated by a towering Madonna of the Trail Statue, one of two on Route 66 (the second is in Albuquerque). In 1909, the Daughters of the American Revolution originally conceived the idea of a memorial to pioneering mothers who traversed the continent.

In 1924, Mrs. John Trigg Moss, chair of the DAR national committee, submitted plans for the erection of twelve statues, one in each state through which the National Old Trails Highway passed, created by August Leimbach, a St. Louis sculptor. Dedication of the last of the statues took place on April 19, 1929, in Bethesda, Maryland.

The second landmark of note is the Buffalo Inn that dates to 1929. Fittingly, buffalo burgers are the restaurant's claim to fame.

As Route 66 enters Claremont, it also enters Los Angeles County. Foothill Boulevard, signed as State Highway 66, is pleasantly tree lined for most of its length in this community. While numerous newer businesses in Claremont and other communities to the west have

façades that present an illusion of being built three, four, or even five decades ago, a few are true time capsules.

The Wolfe family opened a market in Claremont in 1917 and relocated to the current location at 160 West Foothill Boulevard in 1935. Even though this was largely a rural area dominated by citrus orchards, olive groves, and vineyards at the time, traffic along Route 66 was such that it necessitated construction of a pedestrian tunnel for the crossing of the street.

In Glendora, Route 66 followed two different courses through the community, first along Foothill Boulevard and later along Alosta Avenue. The theme of new mimicking old, modern, and time capsule business intermingled along the roadway continues along both alignments through Glendora, and in Azusa, Irwindale, and Duarte as well.

Monrovia also has two alignments of Route 66, Shamrock Street and Foothill Boulevard, or the bypass alignment along Huntington Drive. Fascinating and intriguing landmarks abound along both of these.

However, the crown jewel of urban oddities has to be the Aztec Hotel, a historic property that faces an uncertain future. Inspired by the popular book written

TOP
In Monrovia, this vintage service station seems oddly
out of place in the modern era.

ABOVE
In Azusa, the drive-in theater is a memory and
only the sign remains.

OPPOSITE
The future for the quirky and unique Aztec Hotel in
Monrovia is uncertain.

by archaeologist John L. Stephens, *Travel in Central America*, architect Robert Stacy Judd heavily drew upon Mayan themes for the façade and interior appointments but selected the Aztec name for its appeal.

At the time of its opening in 1925, the unusual design garnered critical acclaim and even inspired a movement. The Mayan Theater in Los Angeles, the Beach & Yacht Club in La Jolla, and the Mayan Hotel in Kansas City utilized similar architectural styles. Several companies began manufacturing Mayan-, Aztec-, Toltec-, and Incan-inspired fixtures, furniture, and wall tiles that mimicked the hotel's furnishings.

In Arcadia, Route 66 passes the world-famous Santa Anita horse-racing track, a facility that served as a temporary relocation center for Japanese Americans awaiting transportation to internment camps during World War II. Nearby is the Los Angeles State and County Arboretum. Both facilities were utilized as filming locations for numerous motion pictures, including *The African Queen, Road to Singapore, Charlie Chan at the Race Track, A Day at the Races, and Seabiscuit.*

Route 66 sweeps into Pasadena on Colorado Boulevard, famous for being the course used by the annual Rose Bowl Parade, before turning south toward Los Angeles on five different alignments. Along this corridor are more than a few architecturally unique historic structures, such as the Crown City Motor Company building, 1285 East Colorado Boulevard that opened in 1927 as a Packard dealership. The front of the building featured an ornate façade utilizing seventeenth-century Spanish Baroque elements and a showroom window in the same shape as the company's trademarked grille. These components remain unchanged, a primary reason for its listing in the National Register of Historic Places.

Another unexpected find in Pasadena is the Saga Motor Hotel. Built in 1957, the well-maintained motel is a pristine mid-century modern facility. Harold Zook, a local architect, utilized a dramatic Moorish script in neon and decorative concrete block elements to catch the eye of passing motorists. In 2002, the hotel's distinctive neon signage received designation as a Pasadena Historic Sign.

Connecting Pasadena to Los Angeles is the Arroyo Seco, an area that President Theodore Roosevelt found so beautiful that he reportedly commented, "This arroyo would make one of the greatest parks in the world." With the issuance of an ordnance preserving sixty acres of land, that is exactly what the City of Los Angeles did in 1923. This is the course for the nine-mile (14-kilometer) Arroyo-Seco Parkway, the first modern, limited-access freeway west of the Mississippi River and the only National Scenic Byway in a metropolitan area that carried Route 66 after 1940.

The other alignments connecting Pasadena and Los Angeles are a labyrinth of congested urban corridors peppered with architectural gems, historic locations, and engineering marvels. In some locations, surprisingly, little has changed since these streets carried Route 66 traffic.

The earliest alignment, referenced by area historian Scott Piotrowski, was in use from 1926 to 1931. From Colorado Boulevard, this alignment turned south on Fair Oaks Avenue and connected with Huntington Drive.

Huntington Drive has served as an important transportation corridor for more than two hundred years. In the late eighteenth century, this was the course for the Old Adobe Road. It was also the course for the National Old Trails Highway.

As an interesting historical footnote, some of Huntington Drive has an oversized median. As late as 1918, according to Automobile Club of Southern California publications from the period, this was actually two roads with an urban electric rail line between them. This allowed one roadway to carry traffic while service or maintenance was performed on the other.

Before reaching the western terminus of Route 66 at Seventh Street and Broadway Avenue in the heart of the historic Los Angeles theater district, this alignment followed what is now Mission Road before connecting with Broadway in the Lincoln Heights District. The original terminus framed by the glow of renovated theater marquees was planned as the site of the 2016 Route 66 International Festival.

For blocks in both directions, towering architectural masterpieces shadow Broadway Avenue. Nestled within

TOP
Quirky sights abound along Route 66 between Pasadena and Los Angeles.

ABOVE
Gentrification of the Figueroa Street corridor is transforming a once-neglected and blighted area.

OPPOSITE
The Angels Flight incline railroad stands in stark contrast to the modern skyline in downtown Los Angeles.

are urban gems such as the Grand Central Market that dates to 1917 and in the immediate area are an array of intriguing historic oddities, such as Angels Flight, a century-old incline railroad.

The diversity of landmarks, shops, sites, and architectural masterpieces along this alignment are nothing short of stunning. They alone make the fact that the alignments of Route 66 in the metropolitan Los Angeles area are among the least explored even more puzzling.

Examples include the refurbished Fair Oaks Pharmacy, complete with vintage soda fountain relocated from Joplin, Missouri, and dates to 1915, and the Rialto Theater, scheduled for refurbishment and listed on the National Register of Historic Places, which dates to 1925. Another example is the recently renovated and retrofitted Buena Vista Viaduct known as the Broadway Bridge, which dates to 1913.

The second iteration of Route 66 in the Arroyo Seco area saw service from 1931 to 1934. From Fair Oaks Avenue in Pasadena, it turned westward on Mission Street through South Pasadena, and then turned south on Arroyo Drive. This connected with Figueroa Street, then signed as Pasadena Avenue through Highland Park and connected with Broadway Avenue. The western terminus was still at the intersection with Seventh Street.

The next alignment carried traffic for most of 1935 and the first half of 1936. Scott Piotrowski references this as a construction alignment. This alignment followed Colorado Boulevard out of Pasadena and crossed the Arroyo Seco on the picturesque Colorado Street Bridge, an engineering landmark at the time of its construction in 1913.

The course of Route 66 on this alignment underwent a rather dramatic transformation with the construction of the Ventura Freeway. As a result, today, the road makes a sharp curve rather than going straight as it did when it was Route 66.

This alignment then followed Colorado Boulevard into Eagle Rock, an independent community before becoming a part of Los Angeles in 1923. It then followed Eagle Rock Boulevard before turning south on San Fernando Road, also the course for US Highway 6 and US 99, both of which were

historic roadways. It then flowed along Pasadena Avenue before connecting with Broadway Avenue.

Effective January 1, 1936, the western terminus for US Highway 66 became the corner of Olympic and Lincoln Boulevards in Santa Monica. As a result, Route 66 connected with Sunset Boulevard and then Santa Monica Boulevard.

The next alignment received official designation as US 66 in June 1936. It remained signed as 66A or Alternate Alignment until 1960.

This alignment also followed Pasadena Avenue and then turned onto Figueroa Street, utilizing the four Figueroa Street Tunnels to connect with Broadway Avenue via Solano Avenue. Initially the tunnels built between 1931 and 1935 funneled both north- and south-flowing traffic but today are utilized exclusively for northbound traffic on the Arroyo Seco Parkway. Before reaching the city's downtown district and the original terminus of the highway, US 66 followed Sunset Boulevard to Santa Monica Boulevard.

On December 30, 1940, a new alignment of US 66 became official. This alignment followed Colorado Boulevard through Pasadena, and turned onto Arroyo Parkway before joining the Arroyo Seco Parkway. Initial construction of the innovative parkway had commenced in the early 1930s when the Army Corps of Engineers began addressing drainage issues in the area and then actual roadway construction began in 1938.

By modern standards, the curves and short access ramps seem primitive and even dangerous. At the time of its construction, however, it represented futuristic highway engineering.

An interesting aspect of the parkway's construction is the fact that the need to navigate around the pylons of a Santa Fe Railway bridge built in 1896, a bridge now updated that carries the Metro Gold Line, necessitated some of the curves. The road bridges along the parkway bear date stamps from the late 1930s and 1940.

Another engineering marvel of its time was the junction of the Arroyo Seco Parkway and the Hollywood Freeway, a four-level interchange, completed in 1953. Incredibly, in an area known for near-constant highway

OPPOSITE
The Broadway Avenue corridor in Los Angeles is vibrant, colorful, and exciting.

BELOW
Once deemed engineering marvels, the tunnels that funneled westbound Route 66 traffic into Los Angeles still serve as a primary corridor.

BOTTOM
Barney's Beanery has been a part of the Route 66 landscape since 1936.

improvement and evolution, the interchange retains its original form. The freeway funneled Route 66 to Santa Monica Boulevard.

An eclectic collection of landmarks and historic businesses border the Route 66 corridor along Santa Monica Boulevard. These range from the quirky-but-fascinating Hollywood Forever Cemetery and the world-famous hillside Hollywood sign to the 1920s Barney's Beanery and the Formosa Café.

From the beginning of 1936 to decertification in Los Angeles County in 1964, US 66 followed one course from the junction with the Hollywood Freeway: Santa Monica Boulevard through Hollywood, West Hollywood, Beverly Hills, and into Santa Monica, where it terminated at Lincoln and Olympic Boulevards, the junction with US Highway 101A. Myth, and legend, however, has it that the highway ends at Palisades Park overlooking Santa Monica Pier, or at Santa Monica Pier itself.

In part, this is because people find it had to believe that such a vibrant and exciting highway would end at such a nondescript location when just a few blocks away the historic and exciting Santa Monica Pier juts into the Pacific Ocean. Further fueling the myth is a monument to Will Rogers and a dedication to the Will Rogers Highway, Route 66, in Palisades Park overlooking the pier, and a Route 66 sign on the pier that reads "end of the trail."

The latter was originally a movie prop in the 1930s. Dan Rice, proprietor of 66-To-Cali, a Route 66 gift shop on the pier, spearheaded an initiative to replace the sign in 2009. In an interview Rice stated, "We were designing an 'End of the Road' shirt for people who travel the whole road and mark the end of their journeys here. We looked for a sign to put on it that had both Santa Monica and Route 66 history. What we found wasn't much, and we were about to give up when we found this very unique sign. It said three things: Santa Monica, 66, and End of the Trail. It was beautiful."

The replacement of the sign on the pier was a milestone in the highway's history. Today, it has become a favored photo opportunity for Route 66 enthusiasts, a fitting and symbolic end for a grand adventure.

The sign and 66-To-Cali, thanks to the promotional talents and ambitions of Rice, have both become landmarks of the modern era. However, there is one more landmark of note, an unassuming bait and tackle shop at the end of the pier.

The Last Stop Shop on Route 66 is the domain of Mannie Mendelson, who also owns a company that manufactures Route 66 souvenirs and who established a small museum dedicated to iconic Route 66 artist Bob Waldmire in Santa Monica. At the shop on the pier is a simple memorial to the artist, and a legend that reads, "Tribute to Robert Waldmire—The Last Stop Shop The End 2448 Miles," a poignant final photo opportunity for what many see as the adventure of a lifetime.

In discussing his association with the pier, Bob Waldmire, and Route 66, Mendelson noted, "My grandmother worked at a shop on the end of the pier back in 1983. After a storm damaged the pier, I opened a bait and tackle shop there as a new business. The Route 66 souvenir business started with one shirt that I designed and sold in 1990.

"Waldmire loved the pier, and over the years we developed a great friendship. During one [of] our last visits together, he gave me a simple painted rock with the signature Waldmire touch, but it was damaged during examination at the airport when I flew home. When I told Bob, he promptly sent another. It is one of my prized possessions. After attending his funeral, I created the memorial at the end of the pier."

The journey through America's heartland from Chicago to the end of Santa Monica Pier on America's most famous highway is usually just the beginning for many enthusiasts. They return home, share the adventure, inspire others to make the trip, and make plans for their next adventure. They attend festivals with a family reunion atmosphere, plan festivals, and eagerly meet with friends made on their travels.

Route 66 is more than a mere road trip. It is truly an odyssey.

ABOVE
Santa Monica Pier is a veritable cornucopia of sites, sounds, and attractions, a fitting end for an epic cross-country adventure.

RIGHT
The historic Santa Monica Pier has served as the traditional ending point for a Route 66 adventure since 1936.

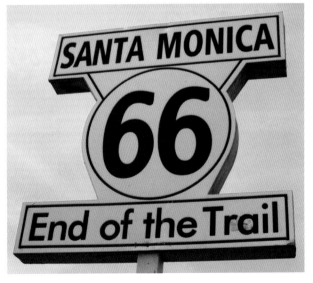

ABOUT THE AUTHOR AND PHOTOGRAPHERS

Jim Hinckley is the author of fourteen books and countless feature articles on topics as diverse as the history of the Checker Cab Manufacturing Company and the ghost towns of the Southwest.

For the book *The Big Book of Car Culture*, Jim and coauthor Jon Robinson received the bronze medal by the association of International Automotive Media Journalists. With publication of *The Illustrated Route 66 Historic Atlas* and the *Route 66 Encyclopedia*, Amazon.com in the United Kingdom began referring to Hinckley as Mr. Route 66.

In 2015 he was inducted into the Route 66 Walk of Fame in Kingman, Arizona, during the Best of the West on 66 Festival, and in the summer of 2016, he was a featured speaker at the first European Route 66 in Ofterdingen, Germany.

Judy Hinckley's passion for photography began with dimes earned in the family store for the purchase of a toy camera, and mushroomed with the patient tutelage of her high school photography teacher, Loren Wilson. As the author's wife and partner, her photography has enhanced the books and presentations that are the cornerstone of Jim Hinckley's America. Together the husband and wife team have chronicled more than thirty years of adventures on Route 66, and on the road less traveled in America and Europe.

Jim and Judy reside in Kingman, Arizona, the proclaimed heart of historic Route 66. They have one son and five grandchildren.

INDEX